Tom Wolfe Carves

EGG HEADS

& Other "Eggcellent" Things

TOM WOLFE

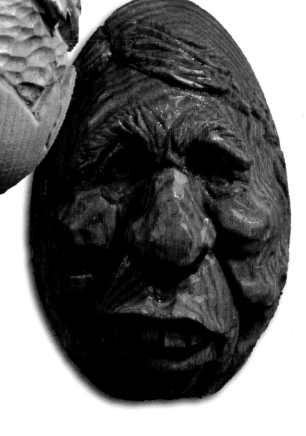

Schiffer Publishing Ltd

4880 Lower Valley Road, Atglen, Pennsylvania 19310

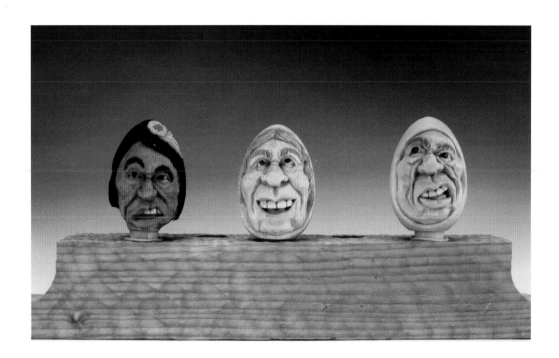

Designed by Stephanie Daugherty
Type set in Zurich BT

ISBN: 978-0-7643-3037-7
Printed in China

Schiffer Books are available at special discounts for bulk purchases for sales promotions or premiums. Special editions, including personalized covers, corporate imprints, and excerpts can be created in large quantities for special needs. For more information contact the publisher:

Published by Schiffer Publishing Ltd.
4880 Lower Valley Road
Atglen, PA 19310
Phone: (610) 593-1777; Fax: (610) 593-2002
E-mail: Info@schifferbooks.com

For the largest selection of fine reference books on this and related subjects, please visit our web site at
www.schifferbooks.com
We are always looking for people to write books on new and related subjects. If you have an idea for a book please contact us at the above address.

This book may be purchased from the publisher.
Include $3.95 for shipping.
Please try your bookstore first.
You may write for a free catalog.

In Europe, Schiffer books are distributed by
Bushwood Books
6 Marksbury Ave.
Kew Gardens
Surrey TW9 4JF England
Phone: 44 (0) 20 8392-8585; Fax: 44 (0) 20 8392-9876
E-mail: info@bushwoodbooks.co.uk
Website: www.bushwoodbooks.co.uk
Free postage in the U.K., Europe; air mail at cost.

Introduction

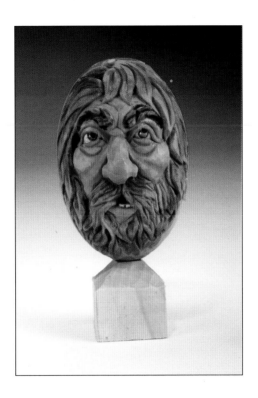

I've cracked a few eggs in my day, but I've carved a whole lot more...wooden ones, of course! They come in a variety of sizes and woods and have within them a slew of characters waiting to be born! All you need is a good imagination and a little practice.

Patterns are not of much use in this kind of carving, and in fact it would be pretty hard to draw one on the egg. Of far more importance is a basic approach to drawing and carving.

I use larger, goose-size eggs for the two projects in this book. Not only is it easier to see in the pictures, it also gives the room needed for detail. Of course, if you like to carry your carving around in your pocket to have something to carve while your spouse is trying on clothing or you are waiting to have your eyes examined, you can use a smaller egg. These eggs were provided from Smokey Mountain Woodcarvers Supply,

Townsend, Tennessee, and are available from them as well as other suppliers.

One of the projects is carved in butternut, a beautiful wood for carving. It holds an edge, but carves a smoothly as bass, and, to boot, it has a beautiful grain. Though I sometimes paint, I usually just give it a good oil finish and let it alone. That's what I've done to the piece in the book.

The second project is from a basswood egg. It seemed right that an egg should have a bird inside, though it is pretty clear that this bird is no chicken! This project needed color, so the white bass gives a good ground for the oil paints I use.

These eggs are all they're cracked up to be! The oval shape lends itself to everything from heads to people to gargoyles to animals. I hope you have fun discovering your own possibilities. If you don't, the yolks on you!

Egghead

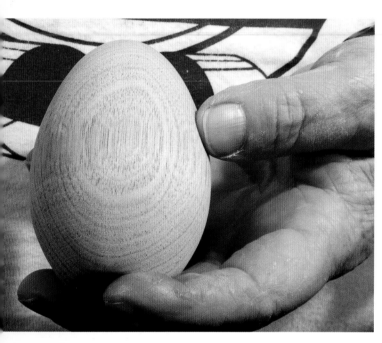

This is a goose egg sized butternut blank. It is big enough to get some nice detail in the carving and has a wonderful grain.

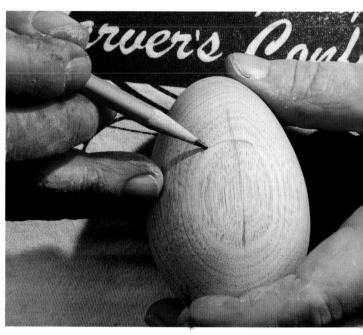

Mark a center line and the line for the eyes.

The flat grain works much better for carving faces than the end grain.

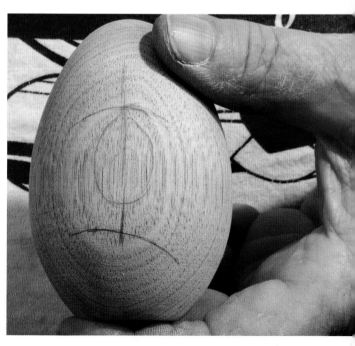

Next I draw in the nose and mouth. I am going for a comical look, so the nose is bulbous and the mouth is at a slant.

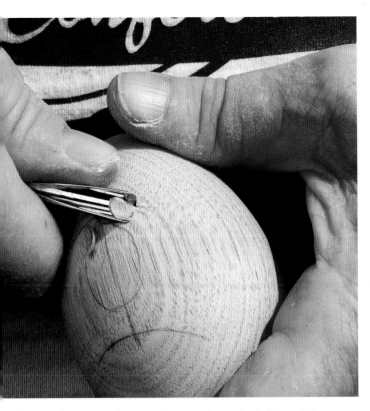

Gouge the eye socket, working out from the bridge of the nose under the brow line, and back at the temple.

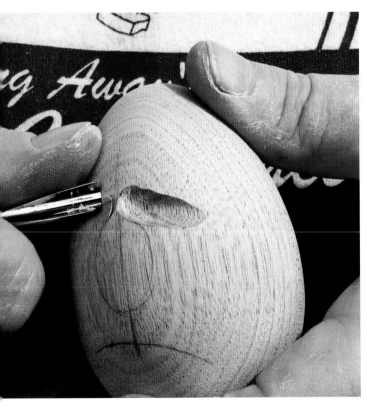

One side done.

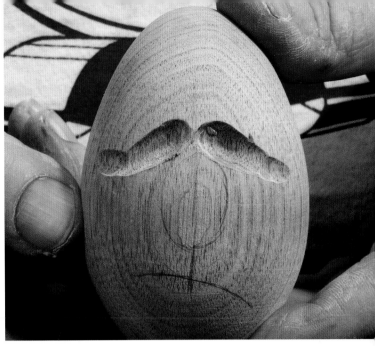

Repeat on the other side for this result.

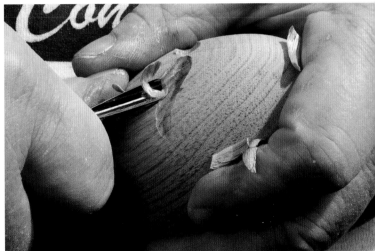

Gouge around the sides of the nose to bring it out.

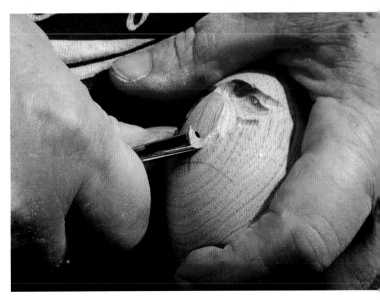

Go across the bottom of the nose with a v-tool.

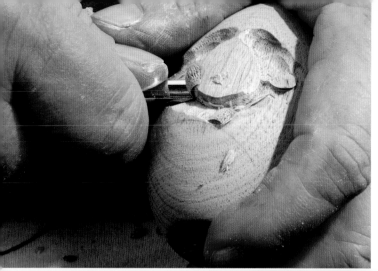

With the gouge, deepen the area around the nose.

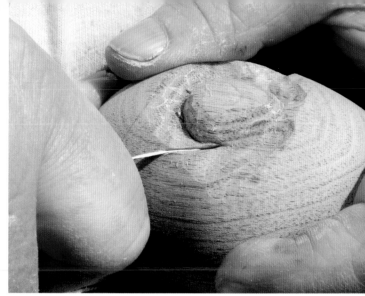

and another along the cheek line

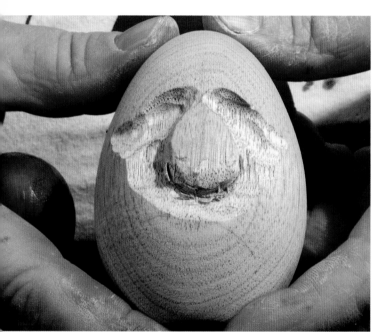

Progress.

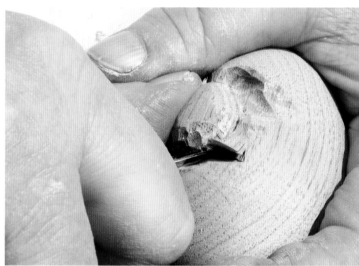

From the lip, slice out the triangle.

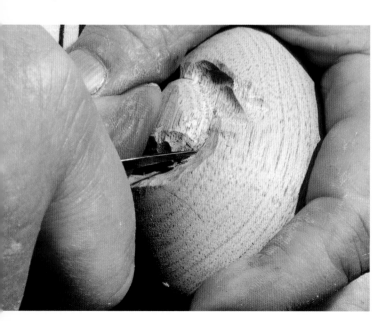

To establish the cheek line, cut a stop along the back of the nostril...

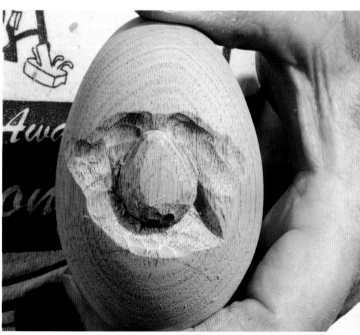

The result. Repeat on the other side.

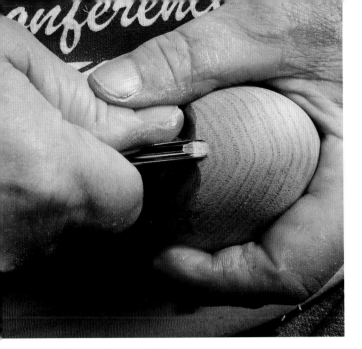

Separate the eyebrows with a gouge...

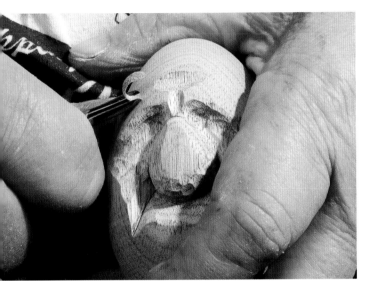

then cut around the top of the eyebrows to bring them out.

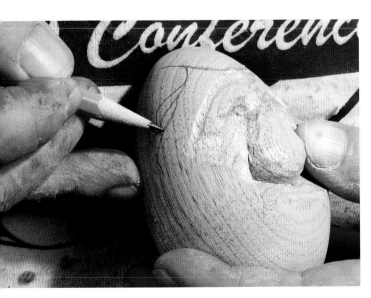

Draw in a hairline.

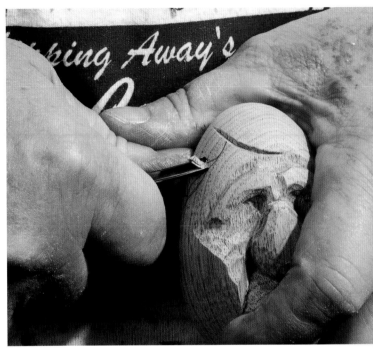

Follow the hairline with a v-tool.

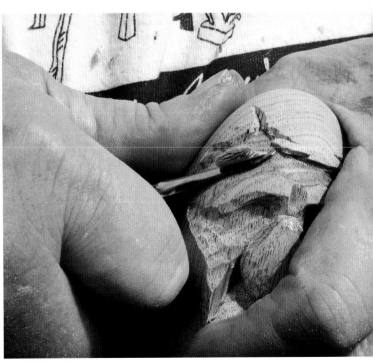

Trim the forehead back to the hairline.

7

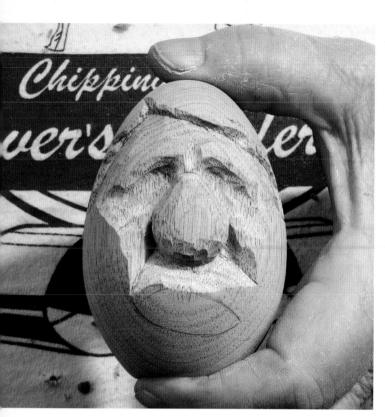

Progress.

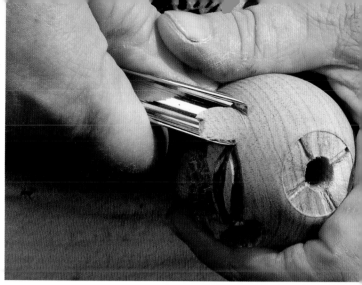

Gouge out the areas beside the mouth to make the cheeks a little smaller and get rid of the some of the egg head look.

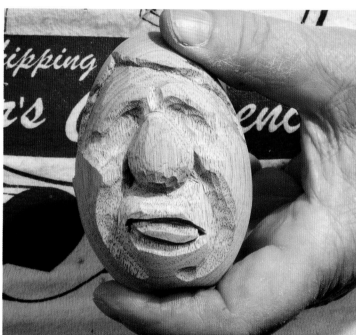

Result.

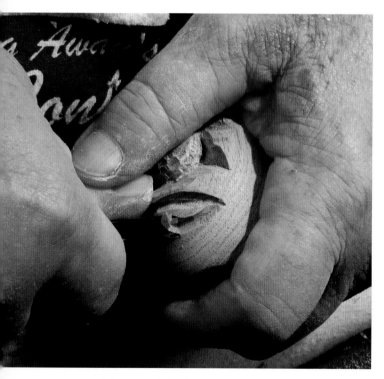

Carve around the mouth. The center portion I am leaving behind can become either the tongue or teeth.

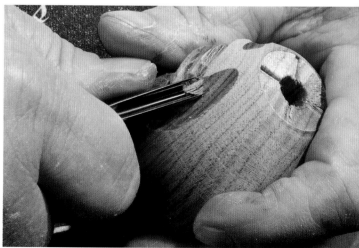

Starting under the corner of the upper lip…

gouge under the lower lip to the middle.

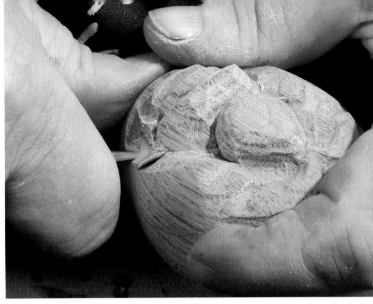

Smile lines add character. Slice along the lower cheek.

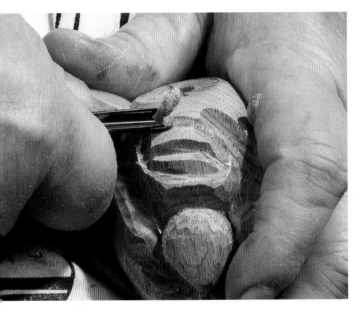

Do the same from the other corner to meet in the middle of the jaw.

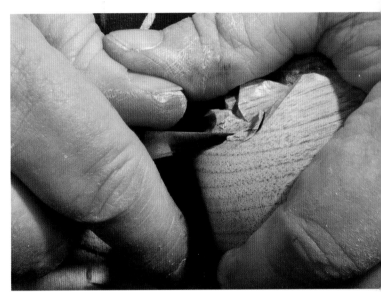

and slice it off…

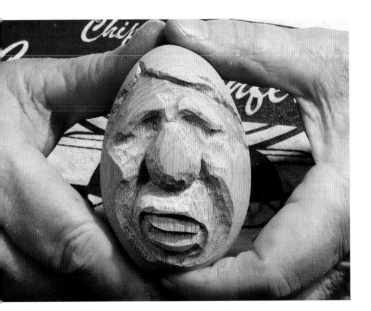

The result. I think the wood we left in the mouth will make great teeth.

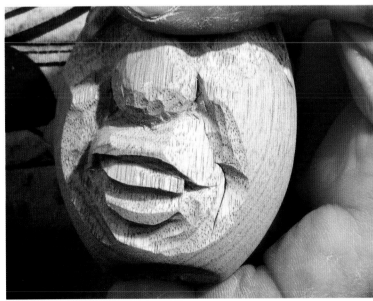

for this result. Do the same on the other side.

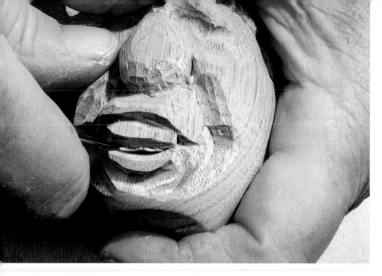

Open the mouth with your knife, to create some shadow.

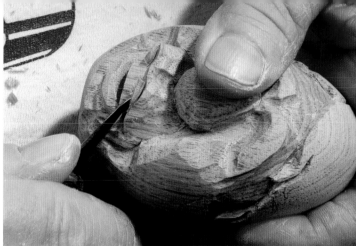

Snip off the wood with a knife.

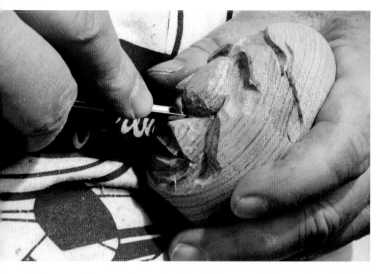

Use a small gouge to make the philtrum, starting at the middle of the upper lip and cutting to the nose.

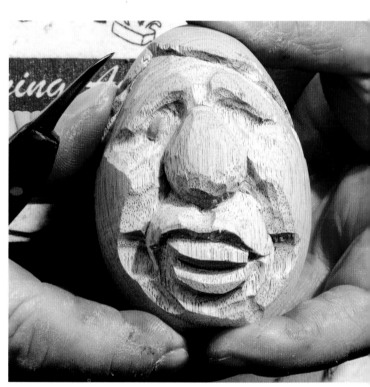

Progress. The upper lip looks quite natural.

On the lower edge of the upper lip, use the gouge to create the little bowing on both sides of center.

Gouge the temple back to the hairline with a good, deep cut.

Use the same gouge to shape the lower cheek. Start at the nose and work to the hairline. You may wish to work from either end of the cut toward the middle.

then the other.

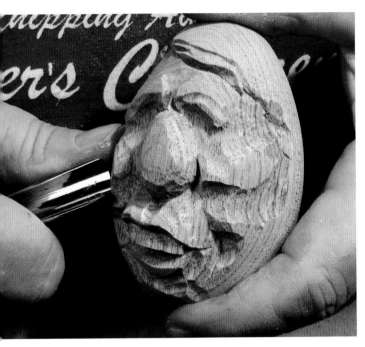

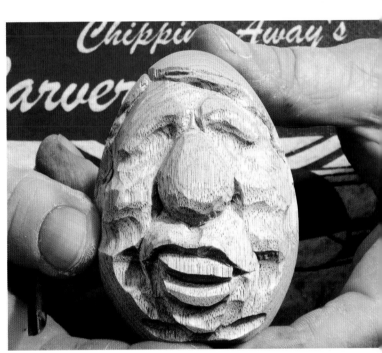

Progress.

Progress. Do the same on the other side.

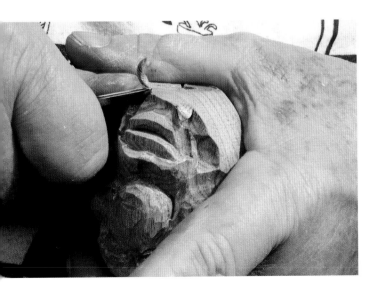

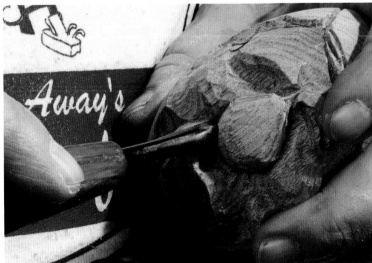

Carve around the chin with the gouge, coming from one side…

Under the nose, cut straight in with a gouge to create the nostrils. Don't pry up or you will break off the side of the nose. Instead, clip them off with a knife.

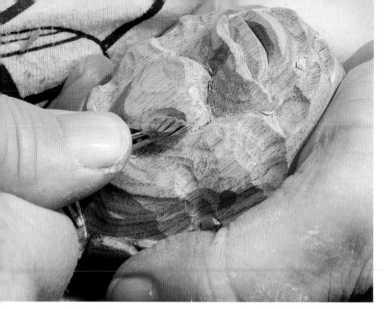

One way to define the top of the nostril is to stick the knife straight in above the nostril and pivot around the point.

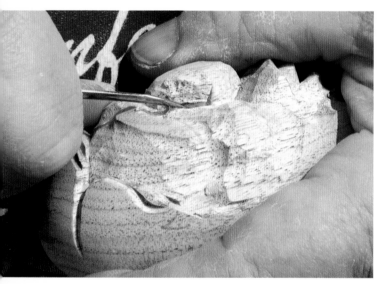

Clip off the resulting chip…

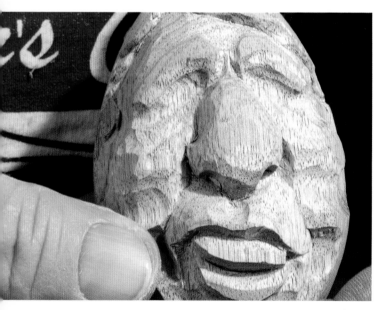

for this result.

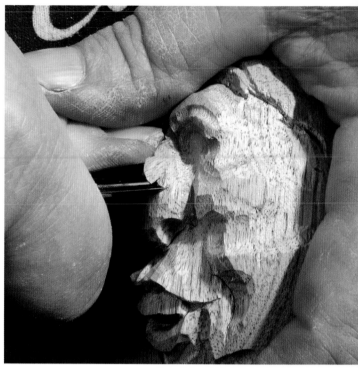

The other way to shape the outer nostril is to cut sraight in with a gouge.

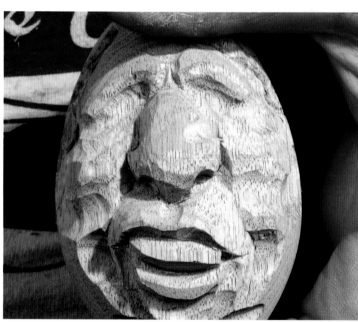

giving this result.

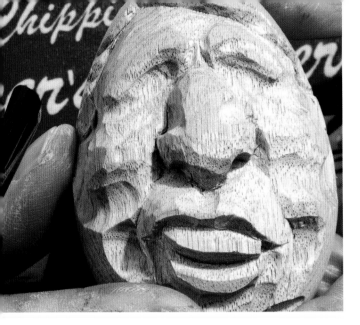

Smooth up the gouge cut.

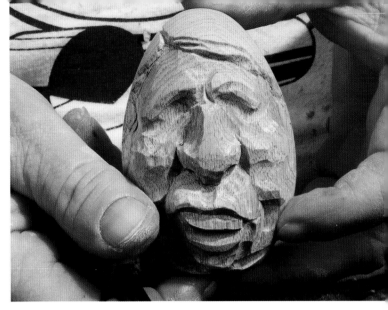

Progress.

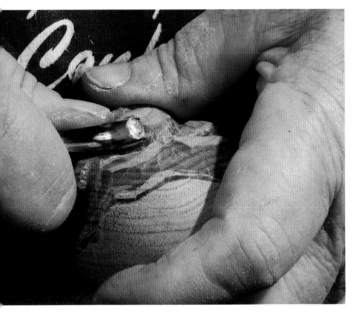

Continue to shape the nose.

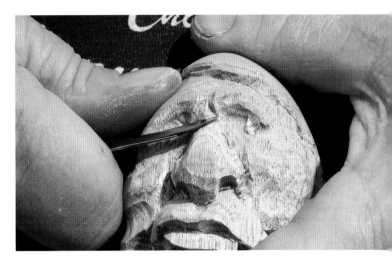

Continue to shape the face. I didn't like the hump on the upper nose...so I'm performing a little rhinoplasty.

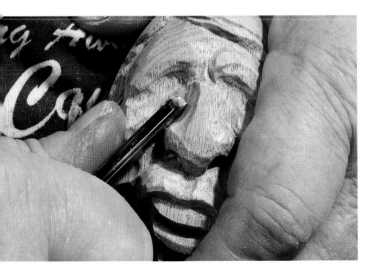

A small gouge will help with the fine tuning of the nose, deepening the line alone the side.

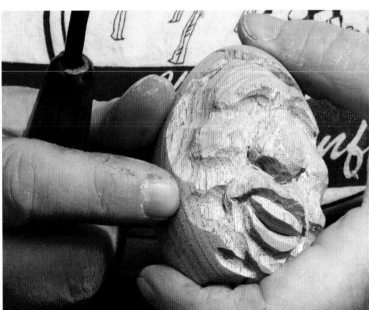

I'm not happy with the jowls, but want to keep this lumpiness beside the mouth.

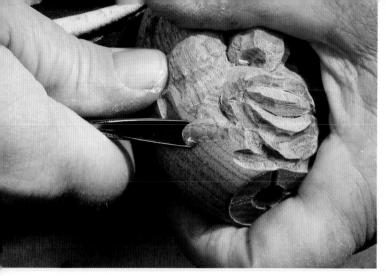

To narrow the jowl, I'll go behind it with the gouge.

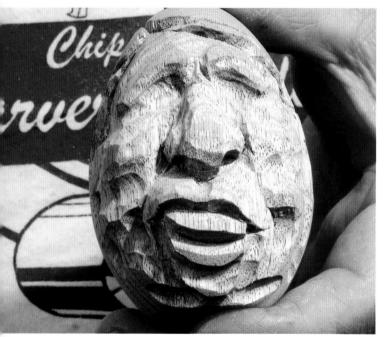

The result is a narrower appearance.

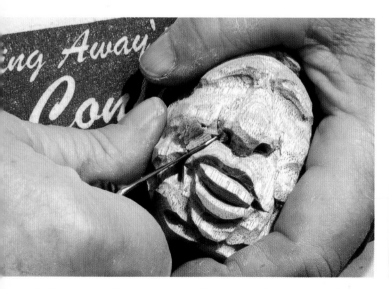

I also want to flatten the upper lip because it was protruding too much into the cheek.

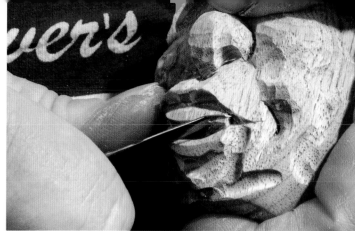

I want the teeth to go up on the left more like they do on the right…

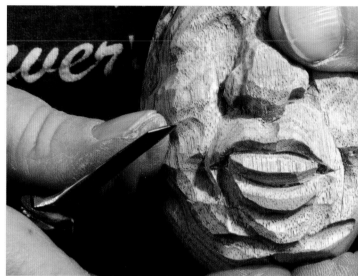

so I clip a little off the bottom.

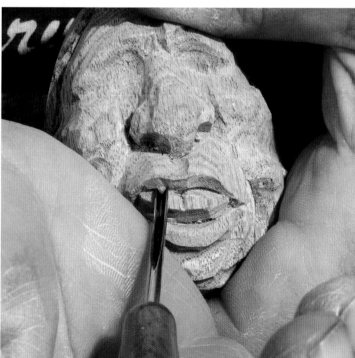

To separate the teeth use a v-tool, starting in the middle and working your way out.

14

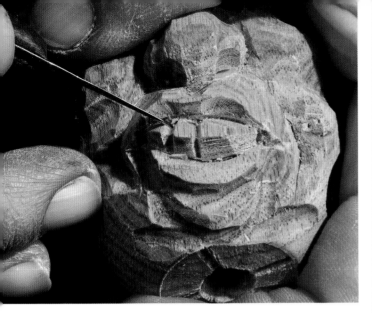

Cutting a small triangle at the top of the spaces between the teeth helps the separation and gives the appearance of gums.

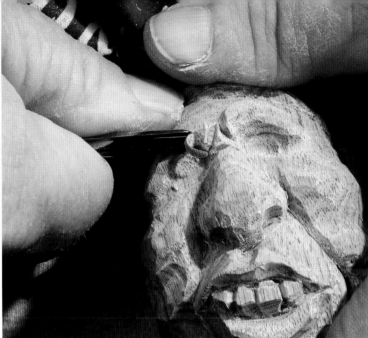

Use a gouge under the eyebrows to bring them out.

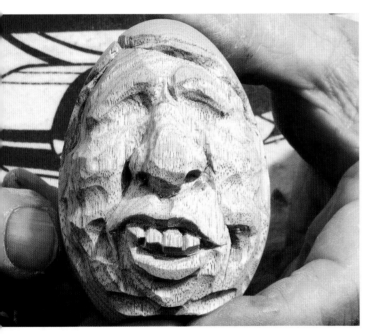

The result.

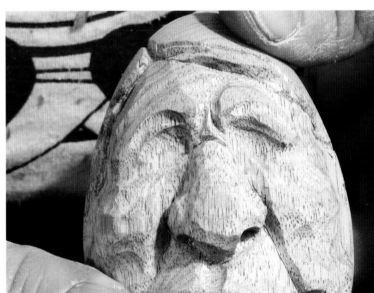

The result.

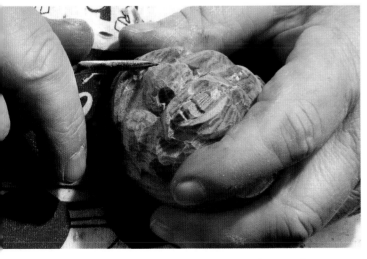

Go over the piece with a knife a smooth out the rough spots.

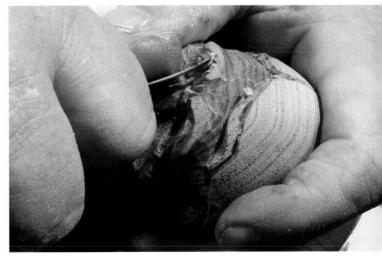

Use a v-tool to create hair lines in the eyebrows..

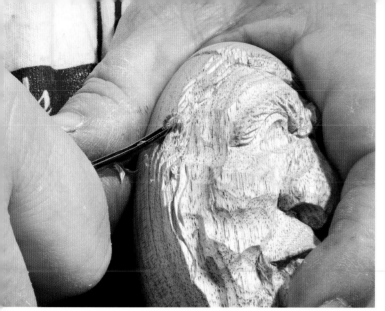

and the head.

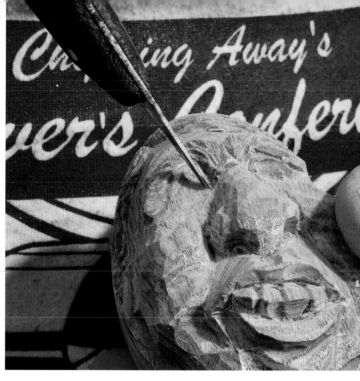

At the tear duct cut out a triangular wedge. Cut down...

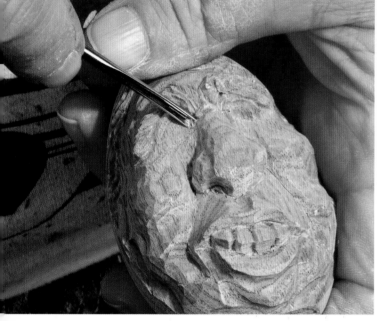

Cut a nitch out of the inside corner of the eye, cutting down first...

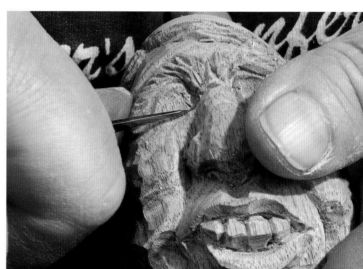

then up...

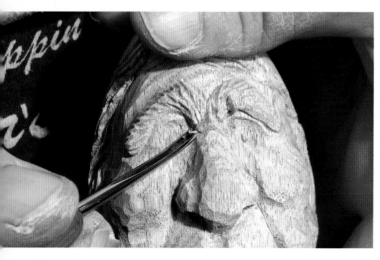

then up.

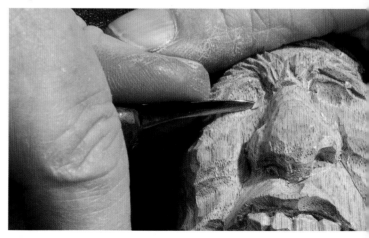

and pop it out the chip along the surface of the eye. Repeat on the other eye.

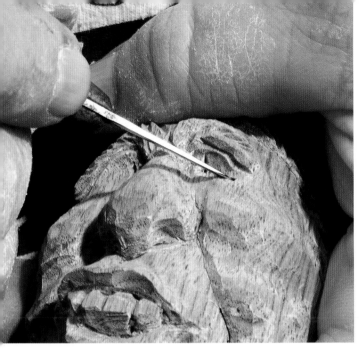

Do the outside corner the same way. Cut across the bottom…

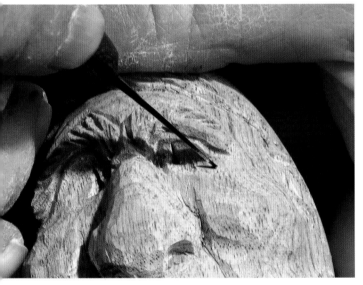

down…

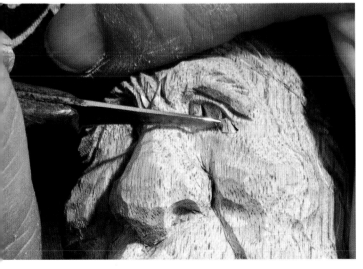

up…

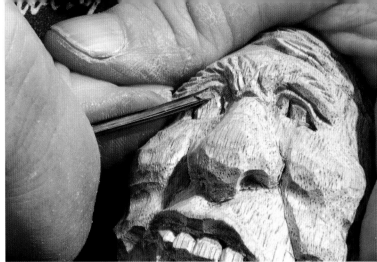

Go under the upper eyelid with a v-tool.

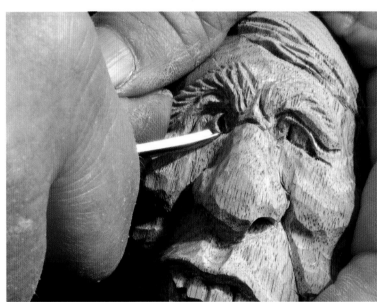

Starting under the upper eyelid, use the v-tool to cut under the lower lid.

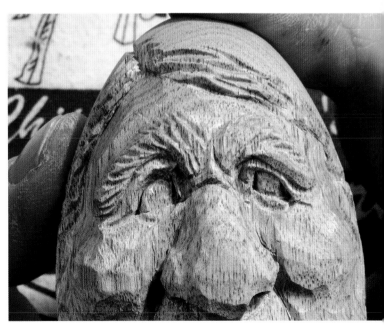

The result.

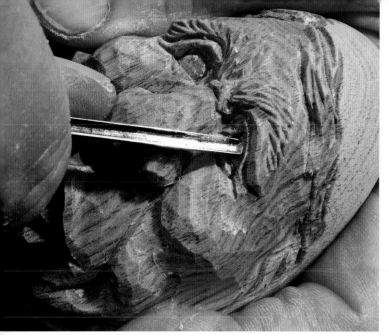

This will not be painted so we'll use the sculptor's trick and use a small (3mm) gouge to cut a pupil in the eye. Push straight in at the top of the iris…

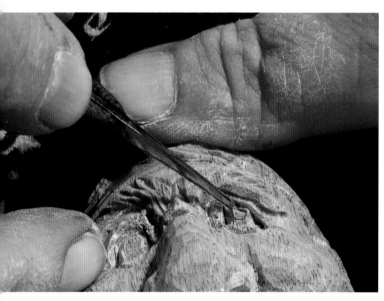

and clip the chip with a knife.

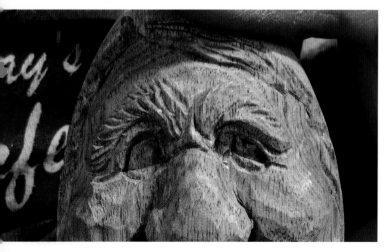

The result. Repeat on the other eye.

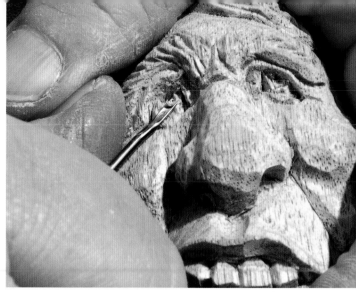

Cut around the lower iris with a micro v-tool to give it definition.

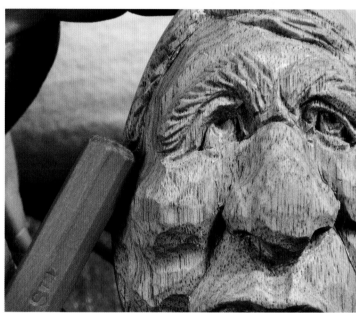

The result.

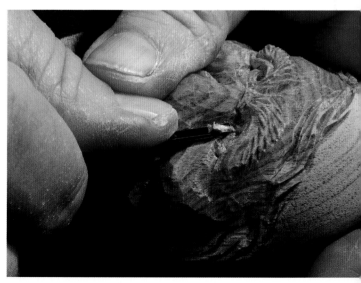

Add another bag under the eye using a v-tool. Work from the center in and out.

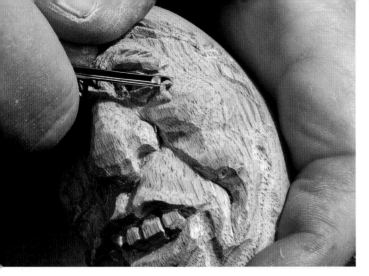

The outer end of the bag will curve to form something of a crow's foot.

One way to apply the finishing oil is dip it.

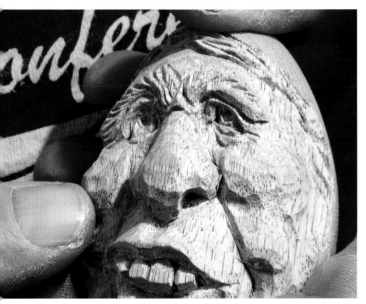

The result.

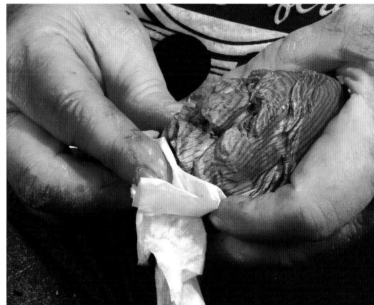

Wipe off the excess.

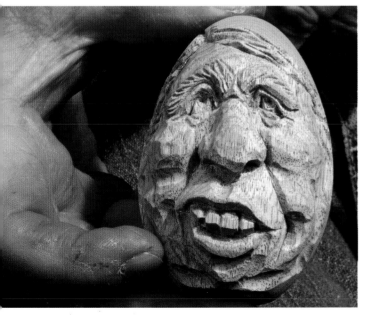

Almost done.

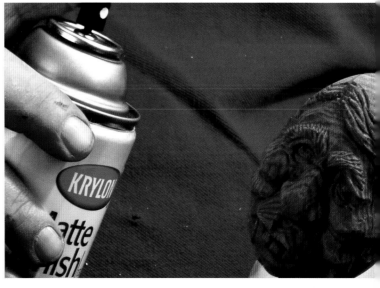

I use a Krylon clear matte finish spray, No. 1311. It will help oil dry faster and act as a sealer.

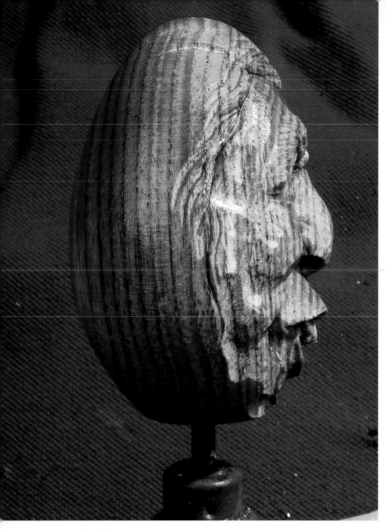
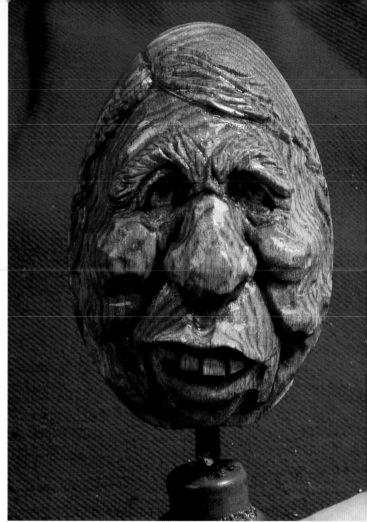

The finished head.

Chicken or the Egg?

Definite proof what came first…the egg. In this case a basswood egg!

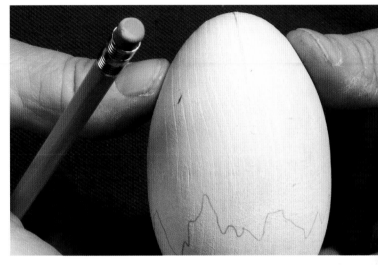

Draw the center line across the top of the head. This time I want the face to go with the grain. The beak will be on the center line and this will give it strength.

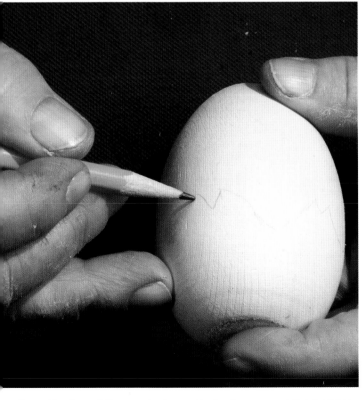

Draw the line of the cracked egg shell edge around the bottom.

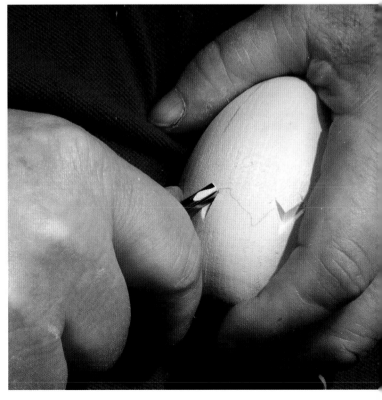

Follow the egg shell edge with a v-tool to make a stop cut.

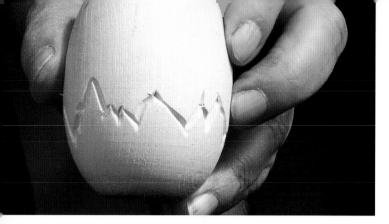

The result.

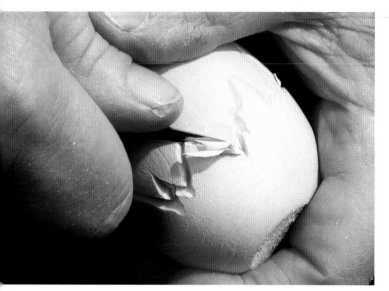

Trim back to the stop from the egg.

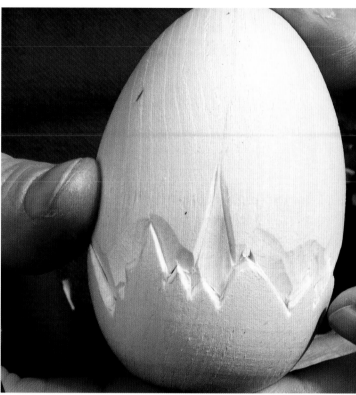

The result.

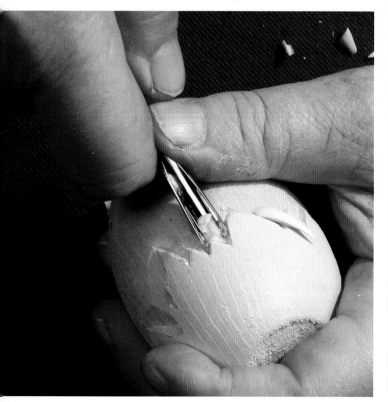

Trim out an area of cleavage where the breast meets the shell.

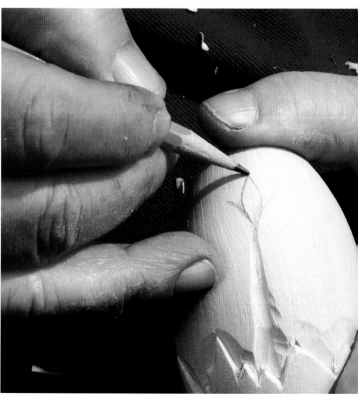

Draw the top of the wing edge and the beak.

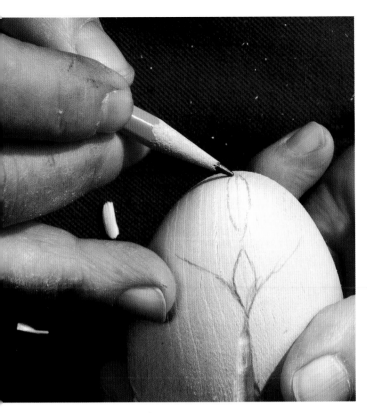

Extend the wings a bit and draw in the comb.

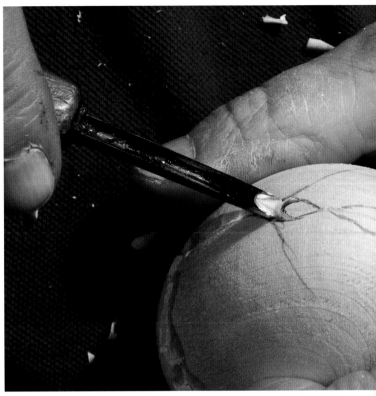

Trim back to it from the wing, cup side up. Repeat at the top of the beak.

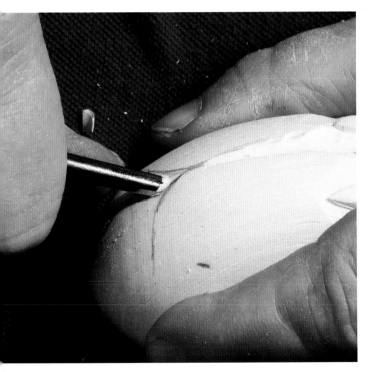

With a small half-round, cup down and make a stop at the bottom of the beak.

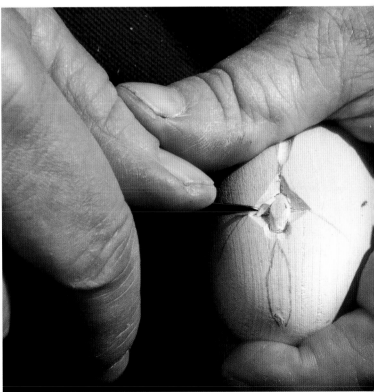

Slice the area around the beak...

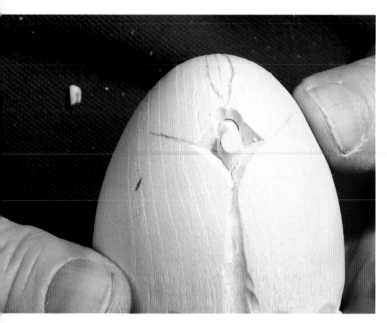

to get this diamond-shape result.

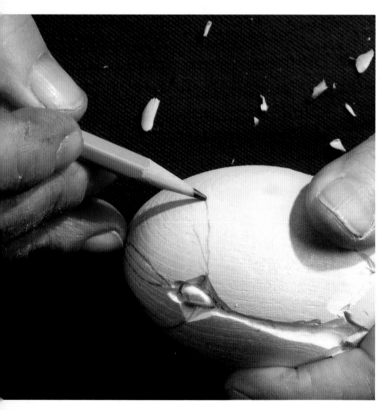

Draw in the neck line

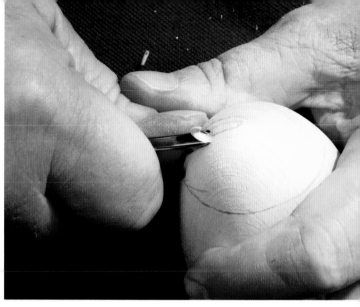

Follow the outline of the crest with a v-tool.

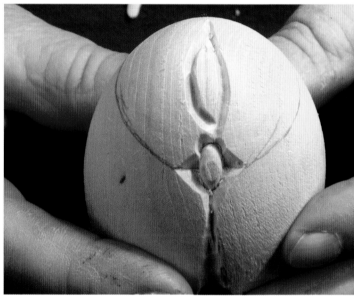

Progress.

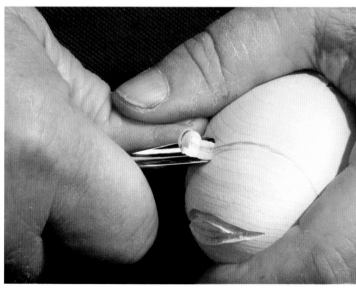

With a gouge, follow the neck line all around.

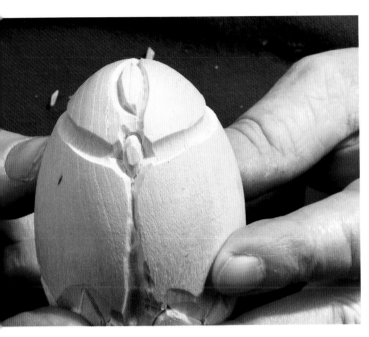

The result.

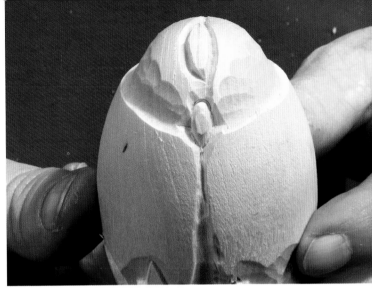

Progress.

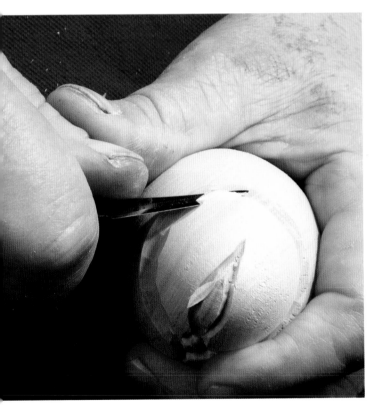

Trim the head up from the neckline.

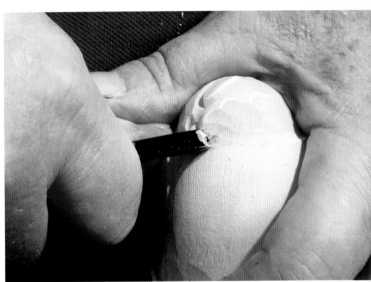

Open up the top of the wing with a gouge.

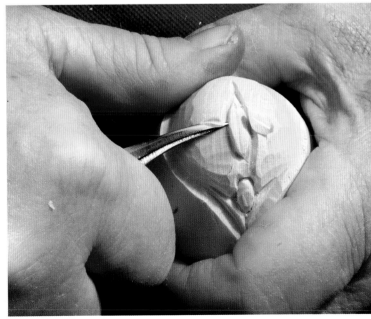

Trim the head around the comb to bring it out.

25

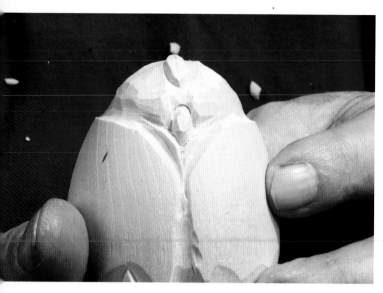

The result.

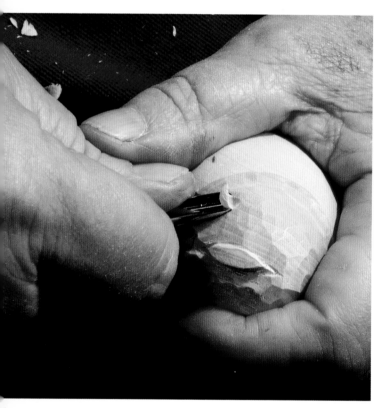

Gouge out an eyesocket on one side

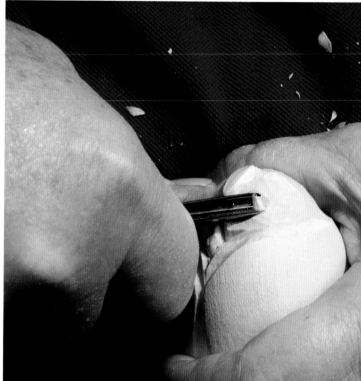

and the other.

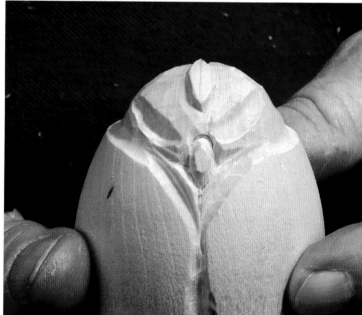

The result.

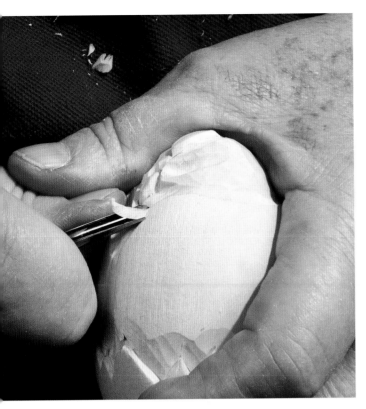

As I continue I see I need to lower the top of the wing so the cheek can come out.

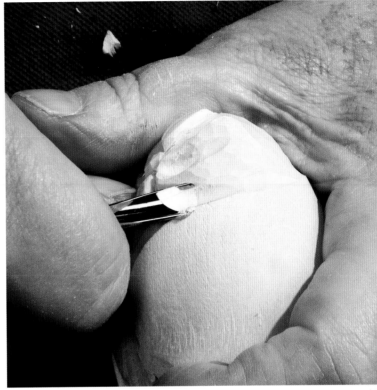

Bring out the cheek by cutting deeper above the shoulder…

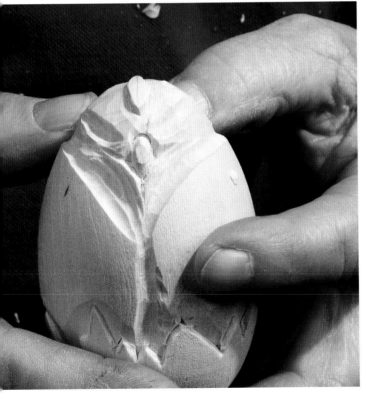

Progress.

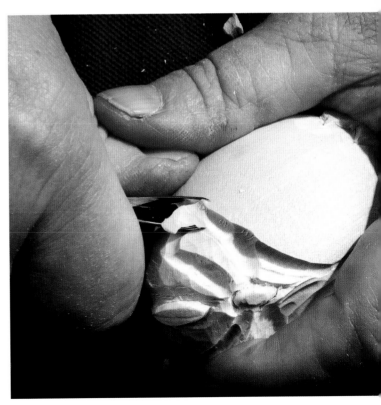

and making a curved cut behind the cheek starting a the back corner of the eyesocket.

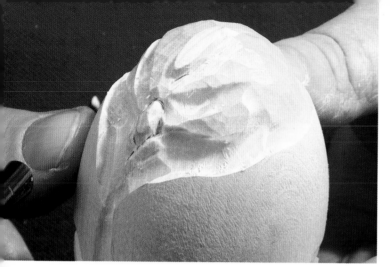

The result.

Follow the line of the wing with a v-tool. I tilt it over so the edge of the wing is flat.

Draw in the font edge of the wing.

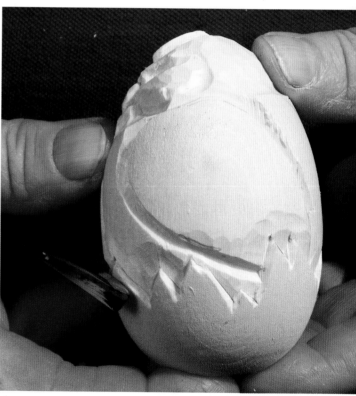

Progress.

At the back draw in the back edge. They lines will meet under the shell.

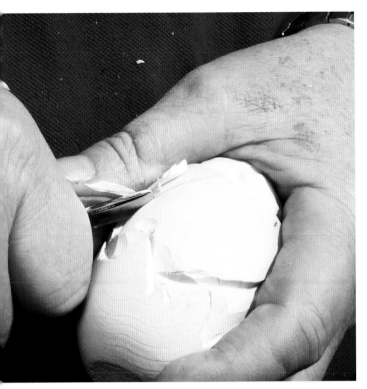

Do the same on the back edge.

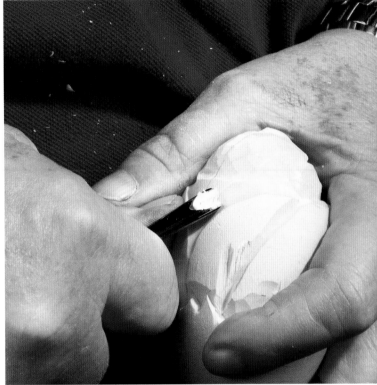

and clean up the neck area in between the shoulders.

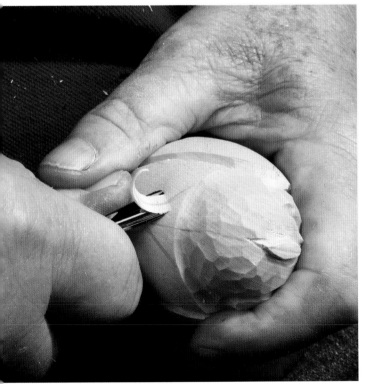

On the back, follow the lines of the shoulder with a gouge…

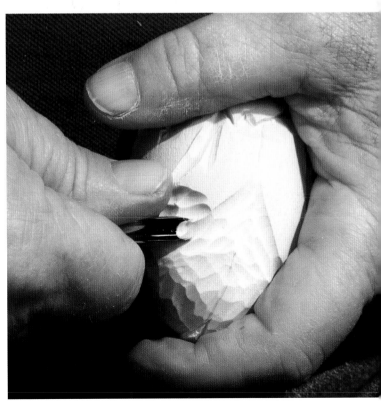

Feather the back, using short strokes with a gouge.

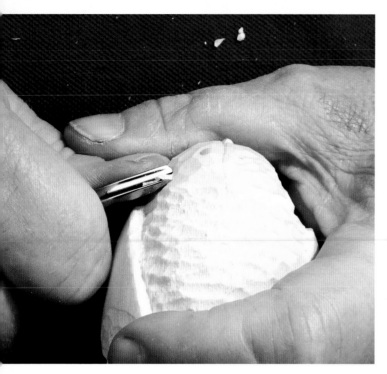

Continue up the neck and head.

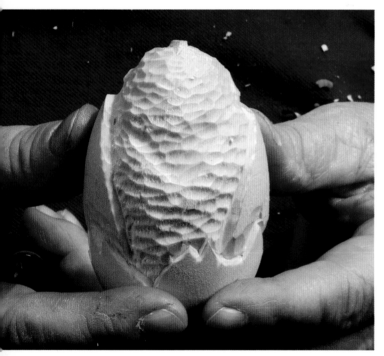

Progress.

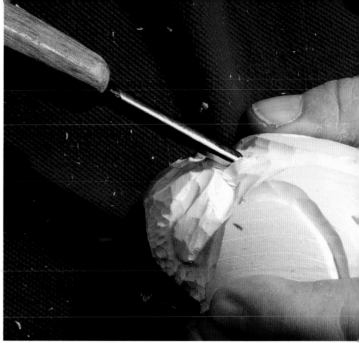

I want to lengthen the beak a little. I start by running my gouge over the end again, cup side down, and pushing it into the chest.

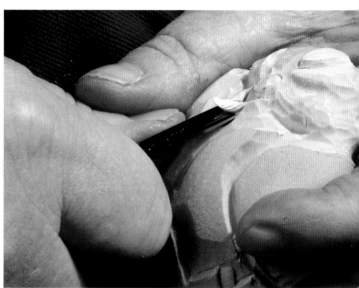

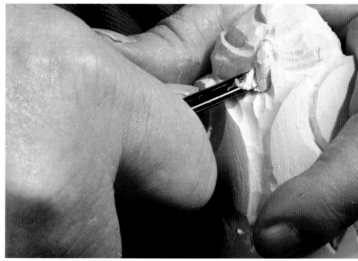

Then I come back and trim back to it.

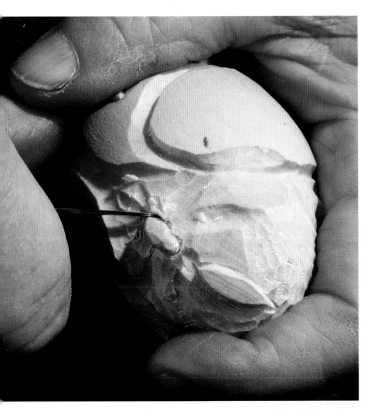

With the beak shape defined, I want to go around and dress it up. A stop along the edge…

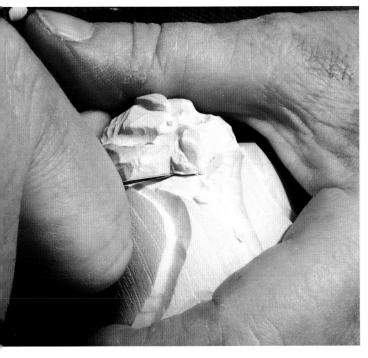

and trim back to it coming up from the chest…

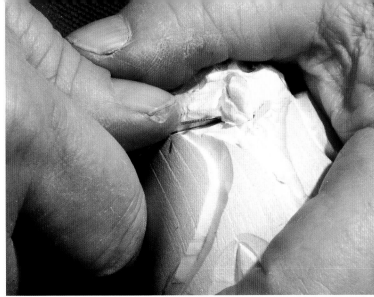

and down from the cheek.

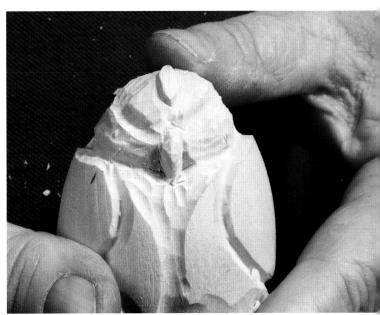

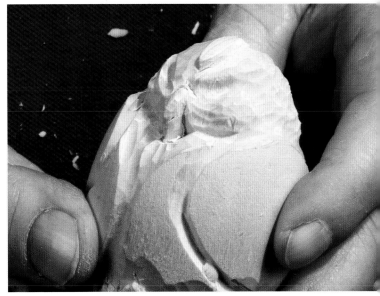

Progress on the beak.

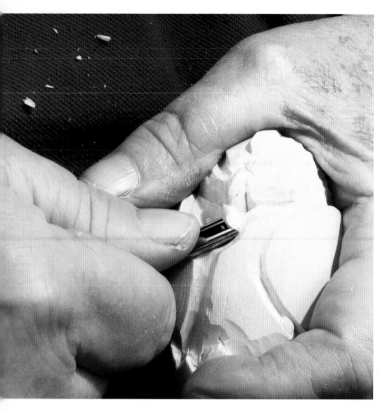

Deepen the area under the chin and beak with a gouge.

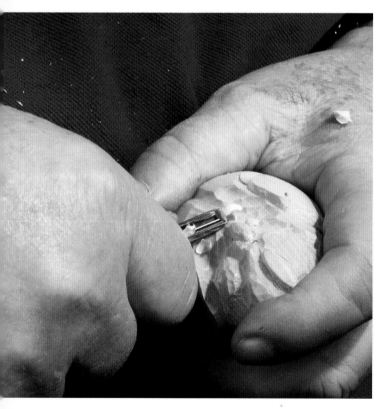

A little breast reduction is next.

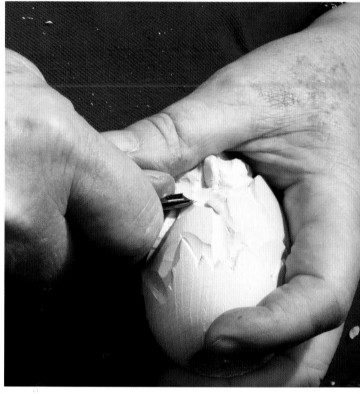

Use the same feather strokes on the breast as you did on the back.

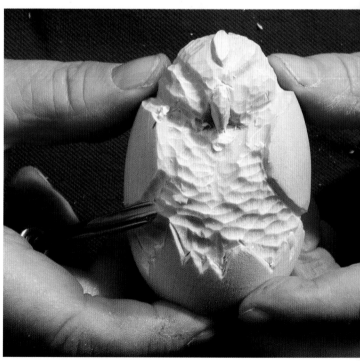

Progress.

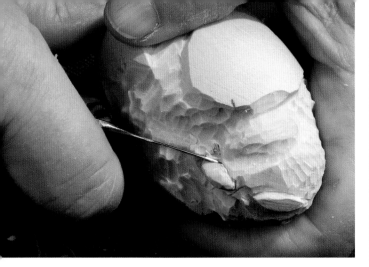

Undercut the bottom of the beak a bit to bring it out...

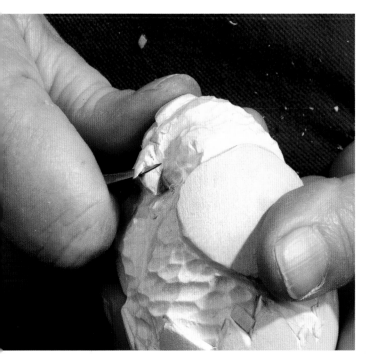

then flatten the front.

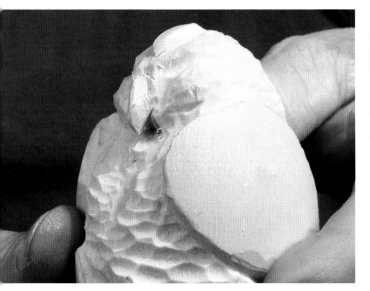

Progress.

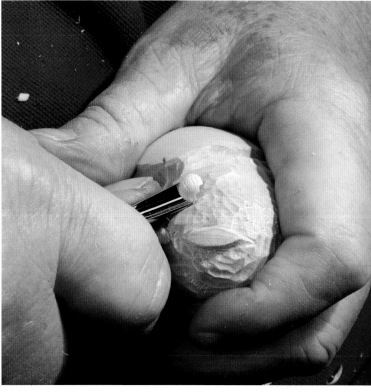

Before working on the eyes I want to open up the socket area. This will let me use bigger eyes.

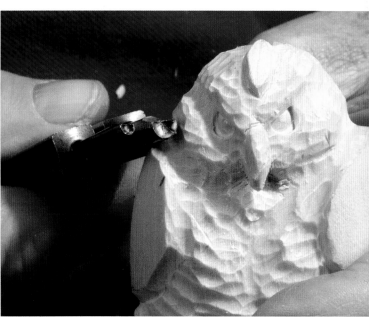

A large eyepunch with a flattened side is used for the eyes. The larger punch is the eyeshape, the smaller the iris.

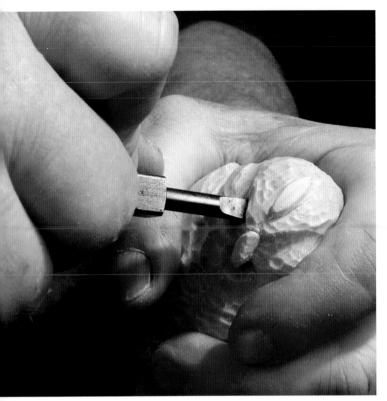

Push it in a rock it back and forth.

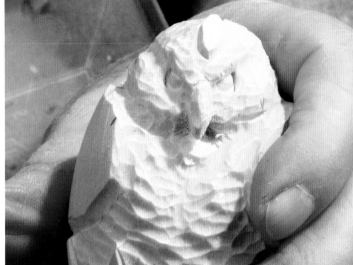

The result.

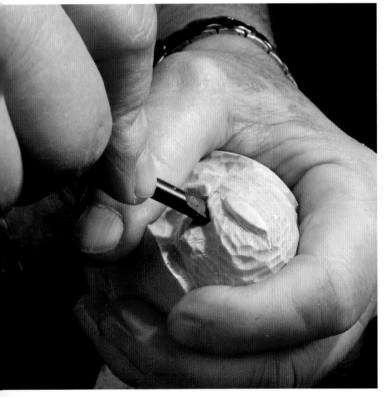

Do the same on the other side.

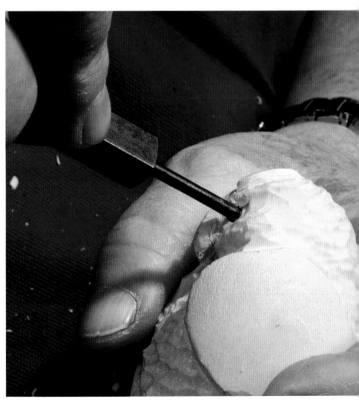

Punch the iris.

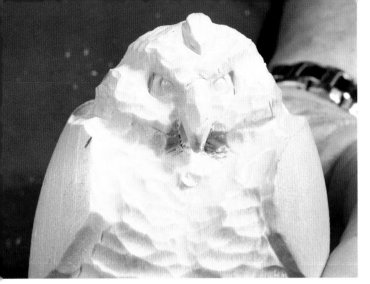

The result.

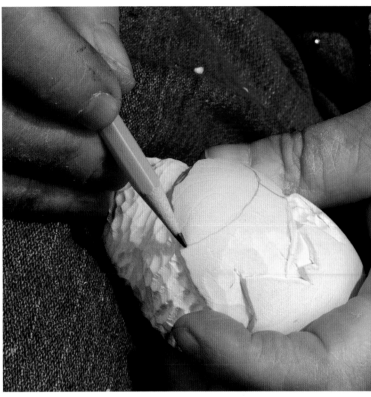

Draw in the feather pattern. The wing butt will have the short stroke texturing.

Use a small gouge to feather around the cheek.

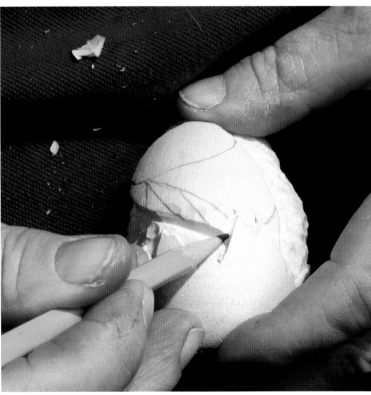

There is a forward segment of flight feathers…

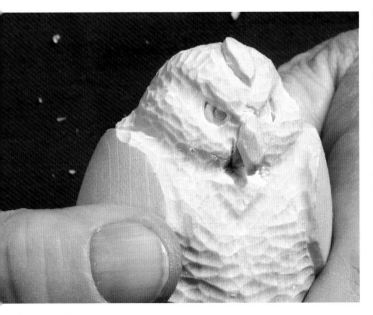

The result.

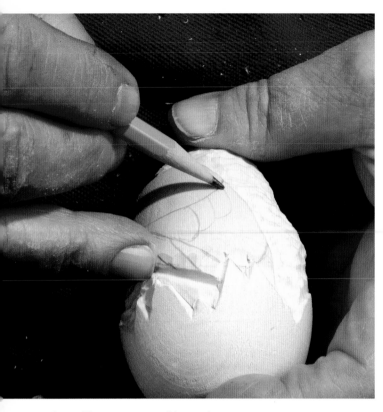

and a trailing segment with two layers...top

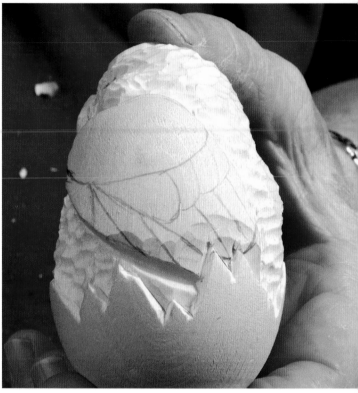

The feather pattern drawn.

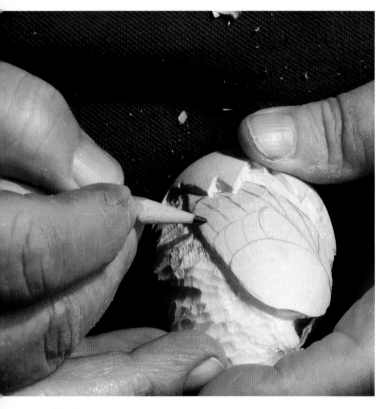

and bottom.

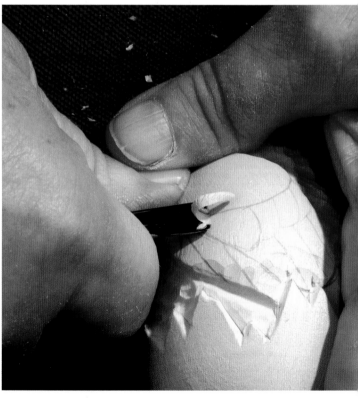

Follow the lines with a v-tool, keeping one edge flat against the lower feather group. This will give a crisp line to the feathers.

36

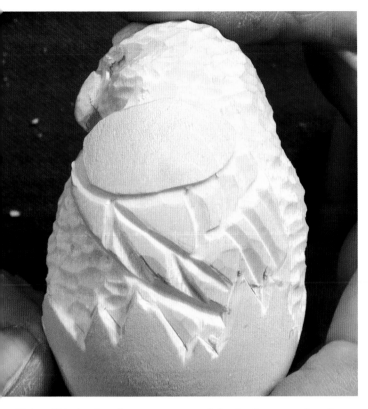

This will help give the appearance of the feathers overlapping.

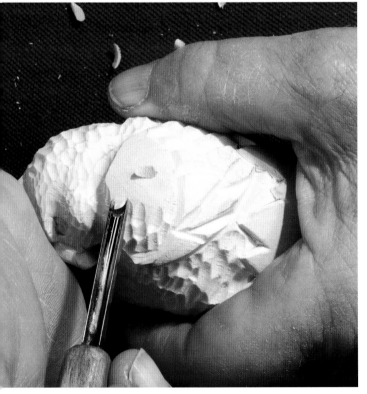

Add the feather texture to the wing butt.

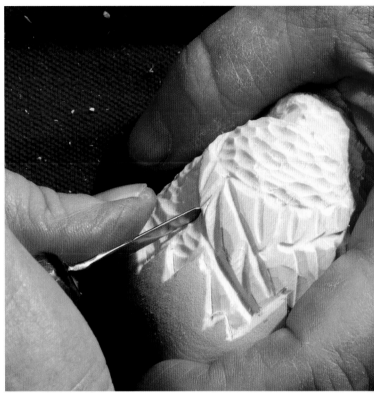

To deepen the feather, make two cuts along the edges…

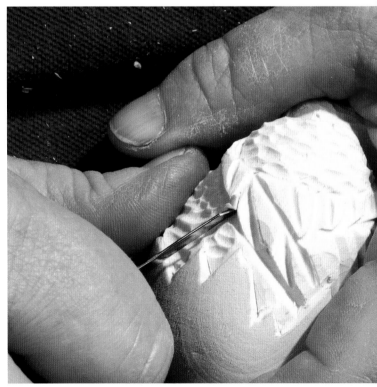

and pop out the chip.

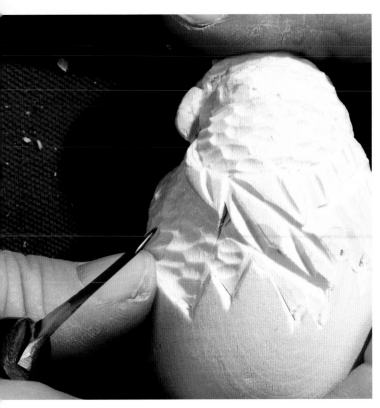

The result is a much better defined feather. Continue as necessary along the lower edge of the feathers and working up.

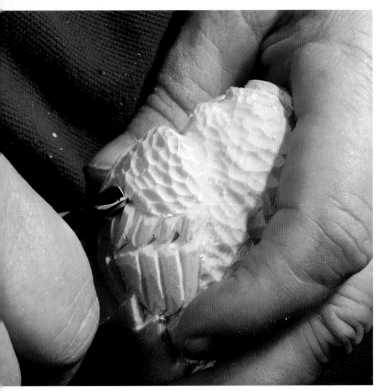

Add veins to the wings with the same v-tool.

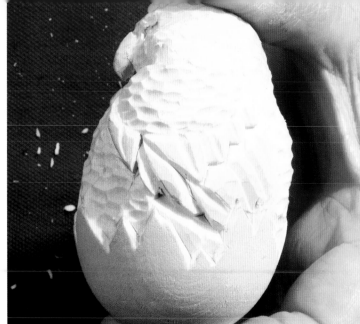

The result.

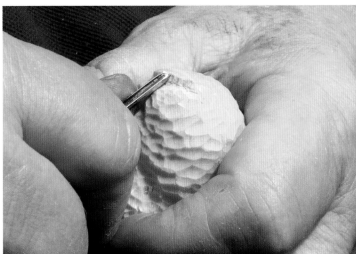

Add texture to the comb with a #9 gouge.

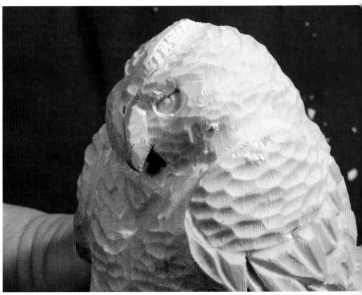

The result.

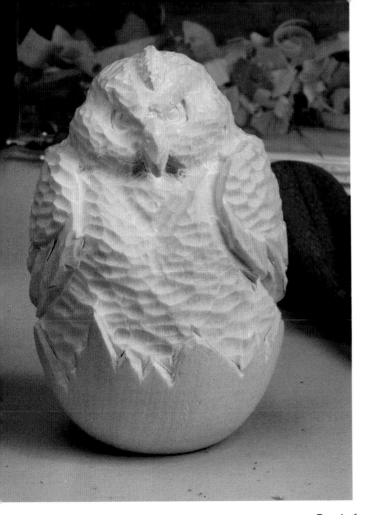
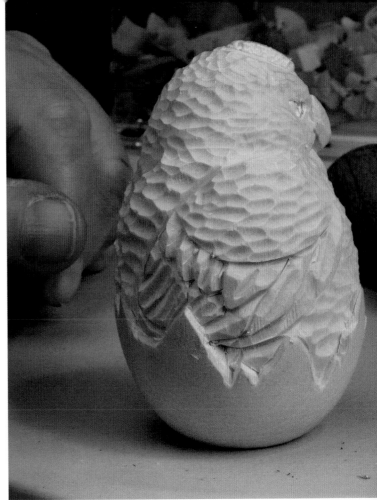

Ready for painting.

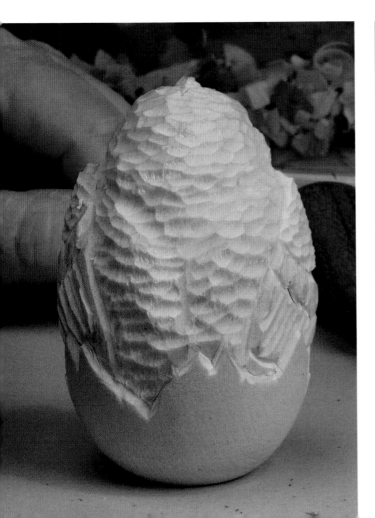
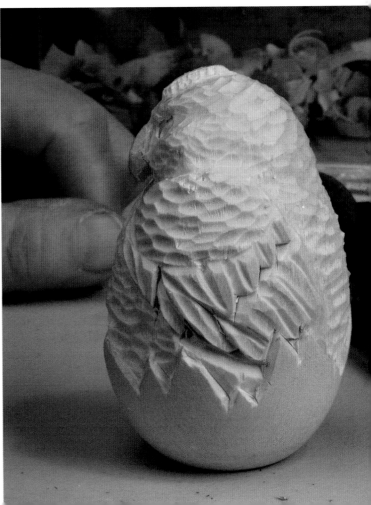

Begin the painting by dipping the carving in linseed oil.

With a tight v-tool under cut the shell. This will keep the body paint from migrating into it, saving a lot of time and frustration.

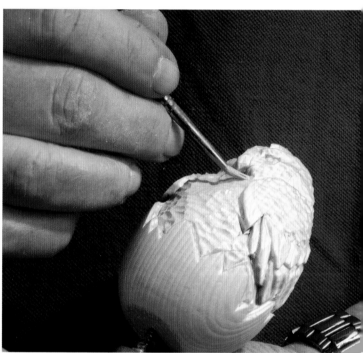

I've chosen gray for the body.

Wipe off the excess.

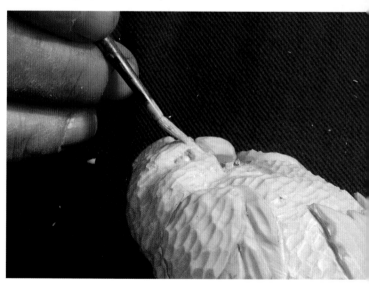

Go around the eyes, beak, and the comb.

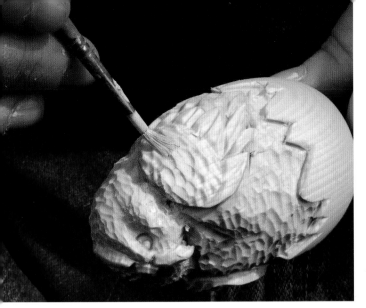

Continue the gray into the wing butts.

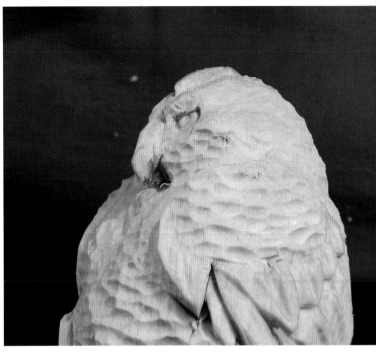

The result.

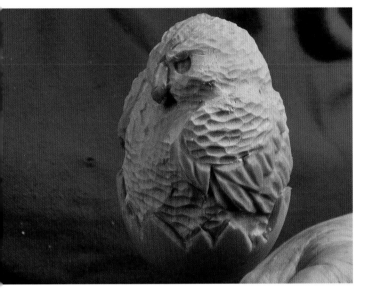

Progress.

The second detail is the nostrils at the top of the beak. Again use the micro v-tool.

As I was painting I noticed two beak details that will help. First the line between the upper and lower beaks. Make it with a micro v-tool

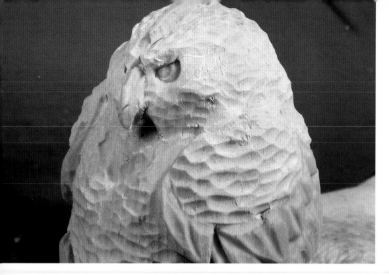

The result. Now back to painting.

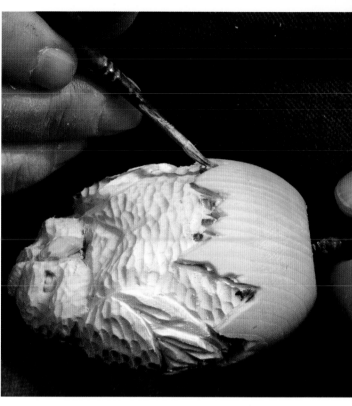

Add some shadow around the shell with a darker gray.

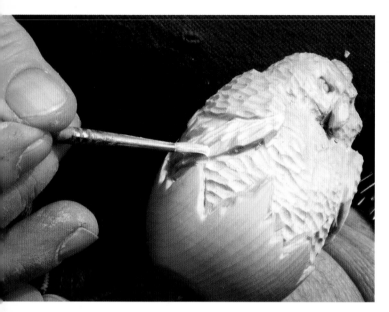

The flight feathers will start with a coat of white.

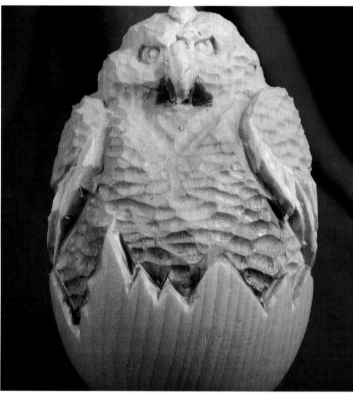

From there blend it into the body, fading out about halfway up.

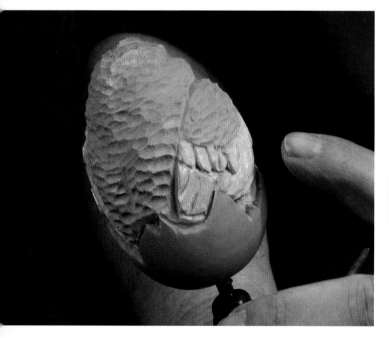

This will be dry brushed with gray after it dries.

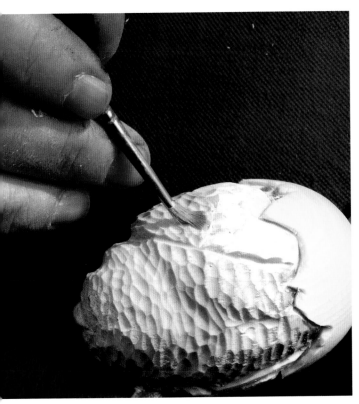

Add some darker color to the edge of the wing butt...

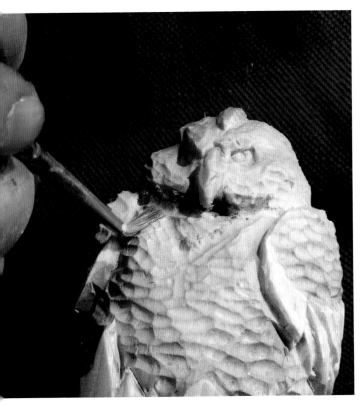

and to add some shadow under the chin.

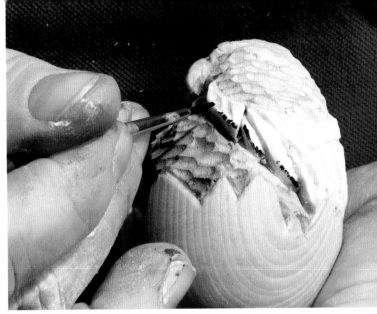

Apply a little black edging to the flight feathers.

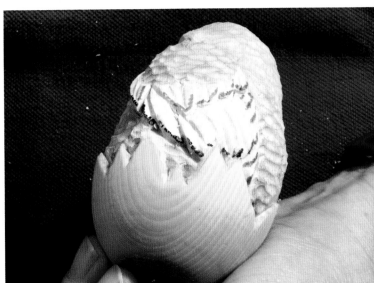

Progress.

Now add some barred rock markings.

43

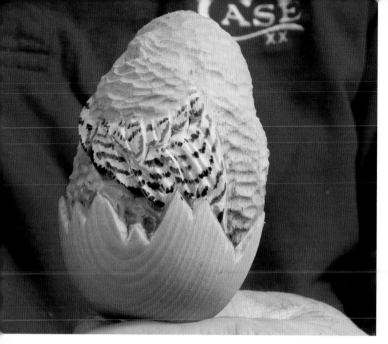

The result.

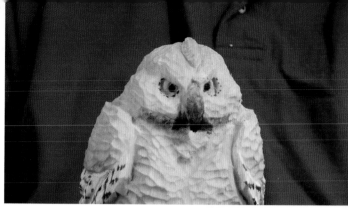

A few dots around the eye brings it to this point.

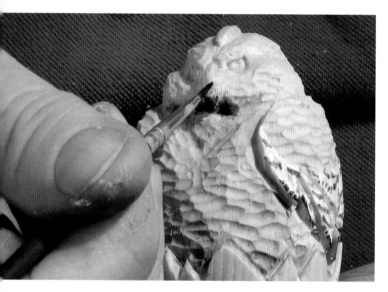

Use the black on the beak too, starting at the tip and fading out as it approaches the face.

The red of the eye and the comb are more easily done with paint pencil. These are made by General Pencil Company under the name Multichrome. After giving it a sharp point, I dip it in turpentine, which activates the paint. I then have a nice pointed painting tool. Apply color to the eyes.

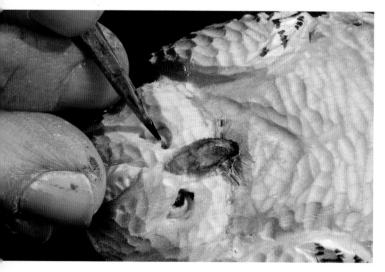

Add the pupil of the eye.

The result.

44

Use the same paint pencil on the comb.

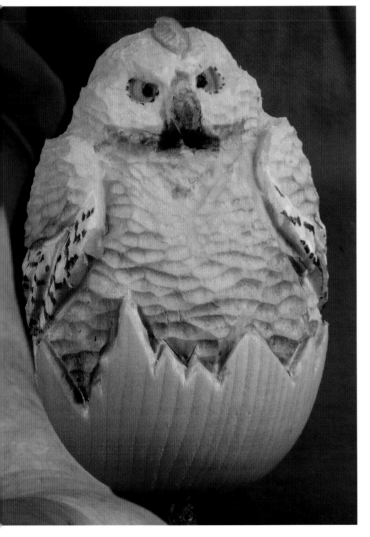

The result.

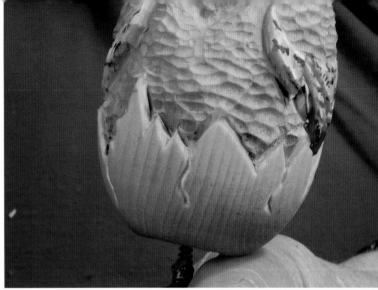

I'll add some cracks to the shell.

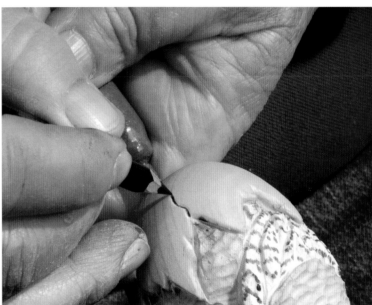

A little color from the black paint pencil will bring this out.

Finally, I am going to drybrush a little white on the upper portions. Fill the brush with paint straight from the tube, then brush it out. I want every bristle to have a little paint on it, but not too much.

Barely touch the brush to the carving so it leaves just a little paint on the highest ridges.

It brings the tool marks out real good.

Also go lightly over the shell...

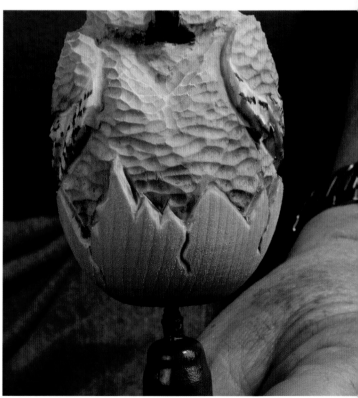

for this result.

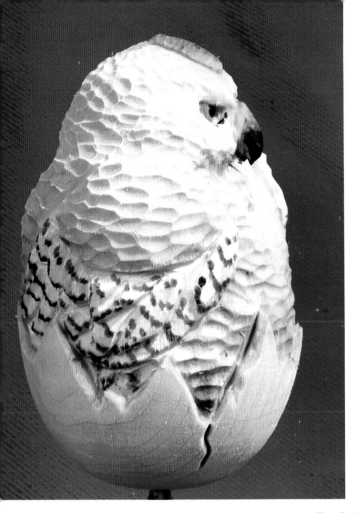
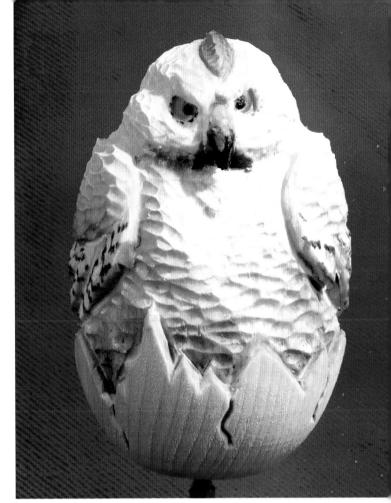

The finished bird.

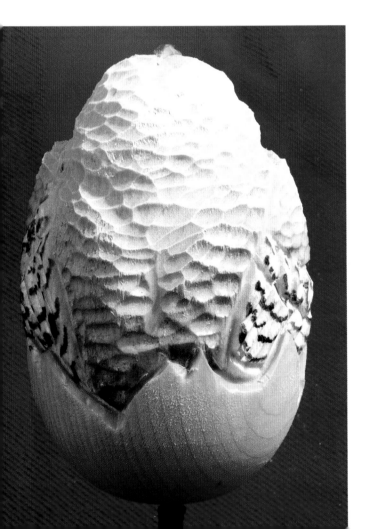
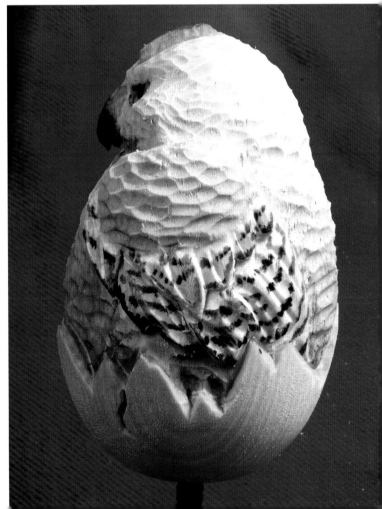

The Gallery

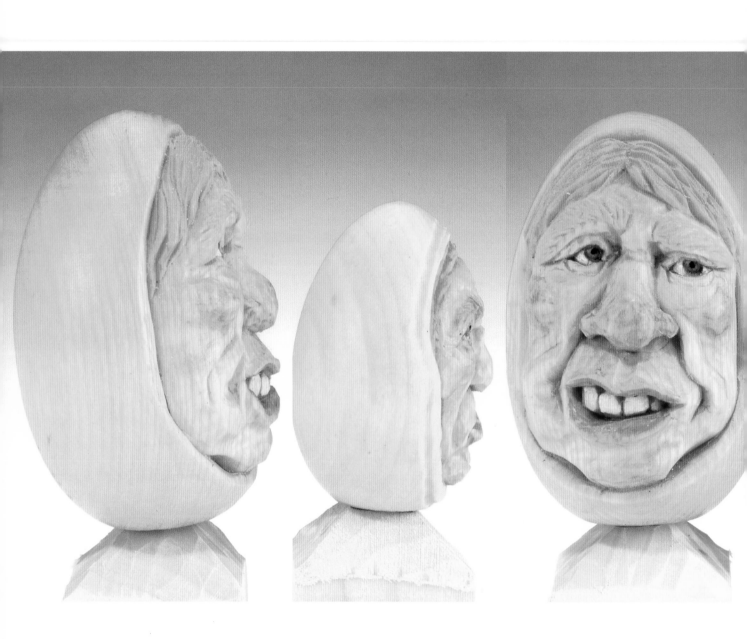

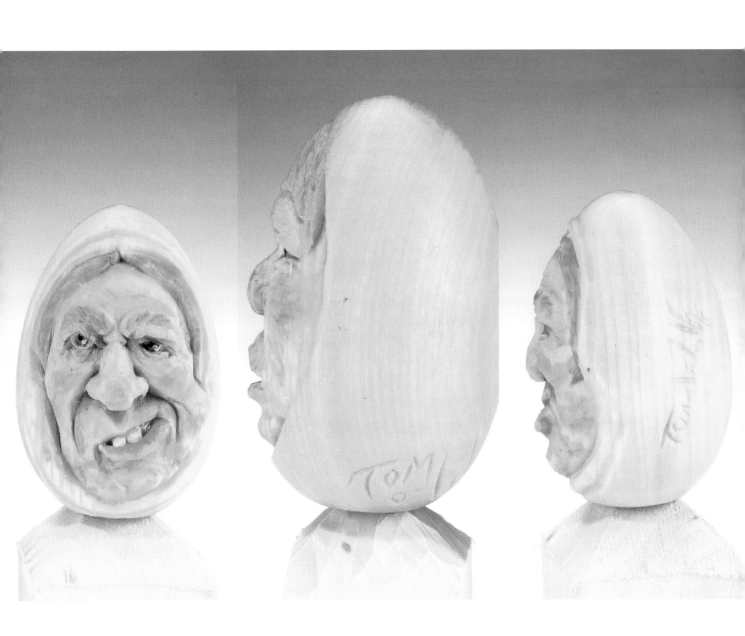

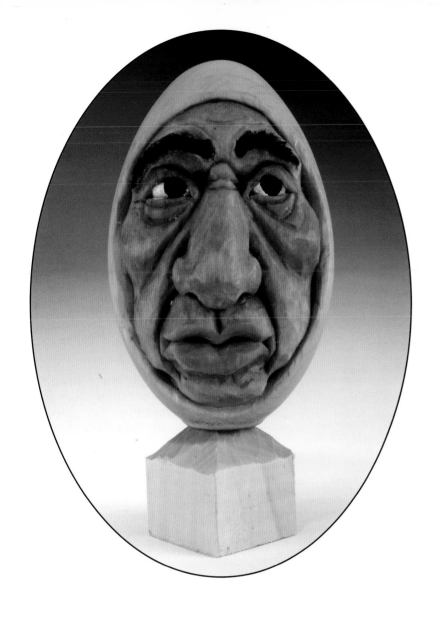
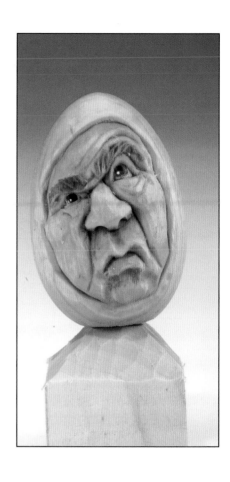

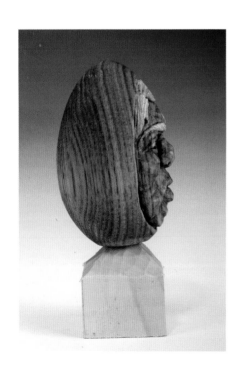
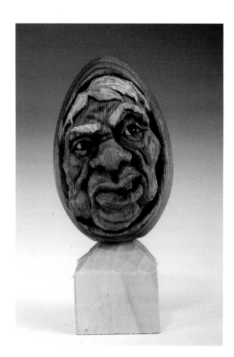
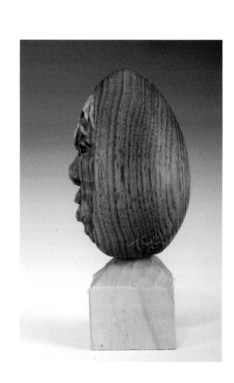

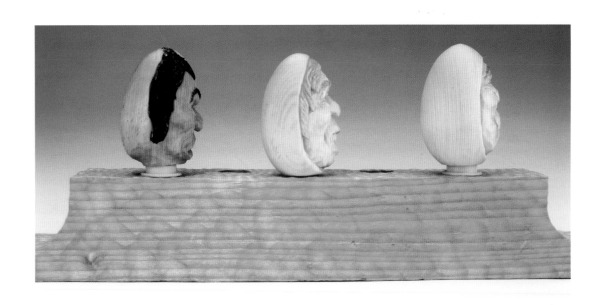

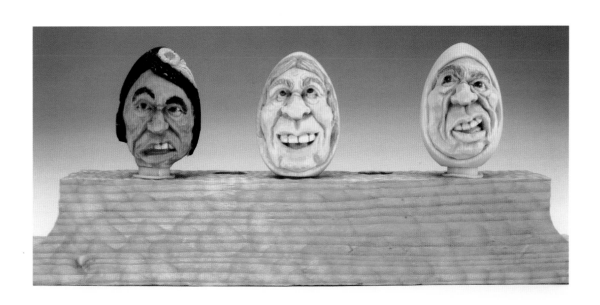

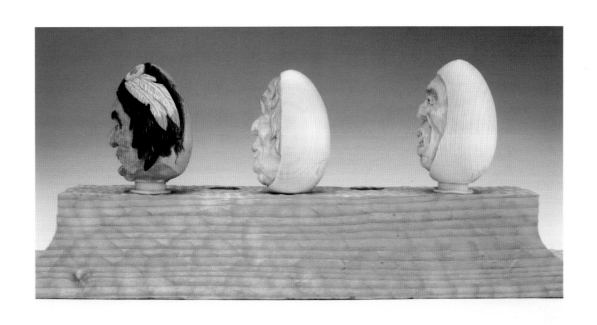

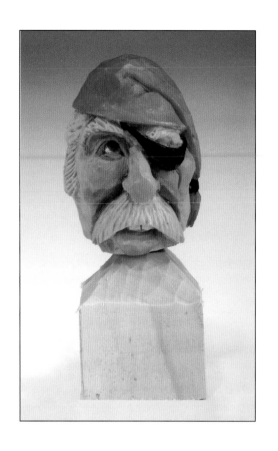

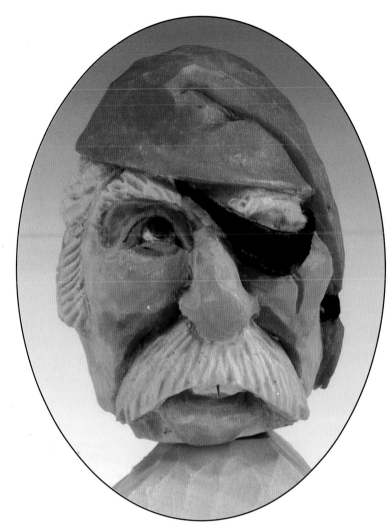

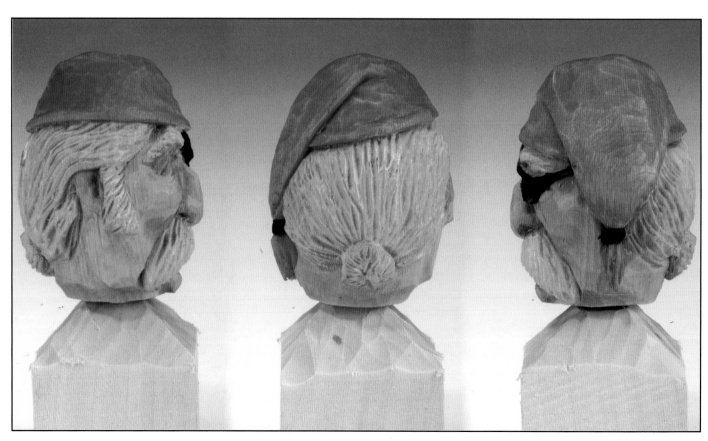

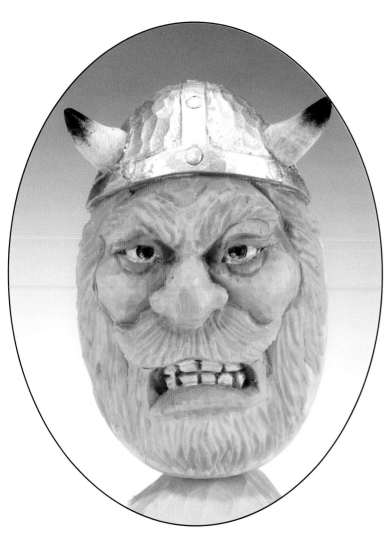

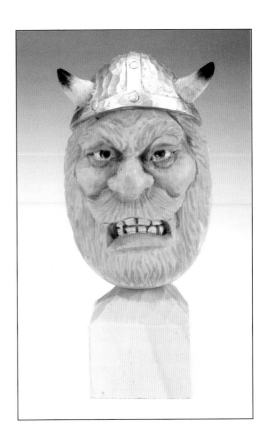

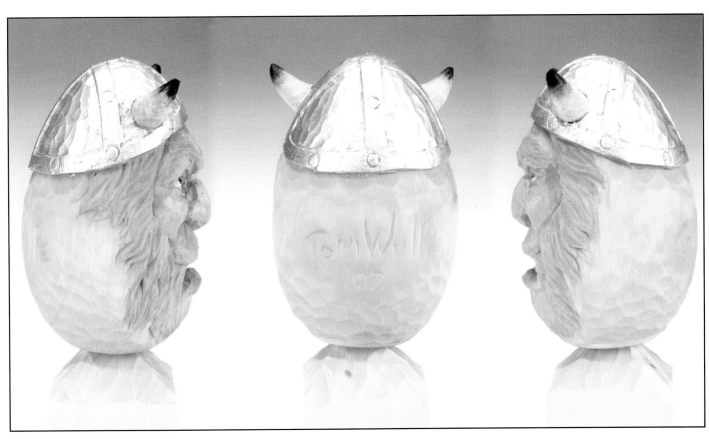

53

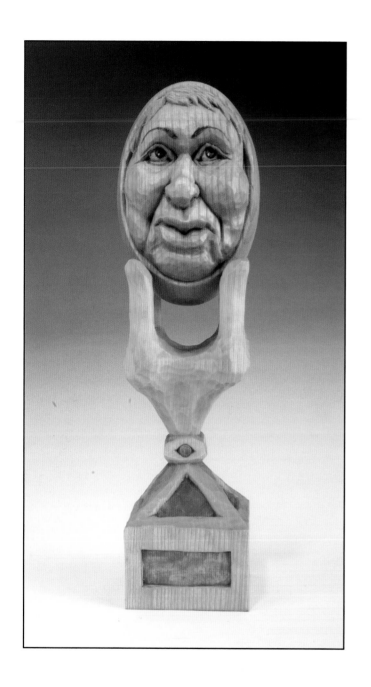

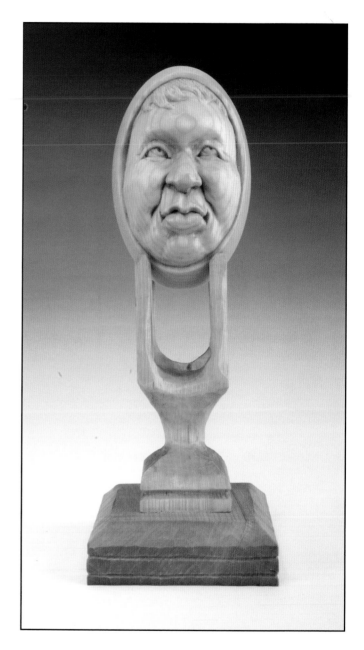

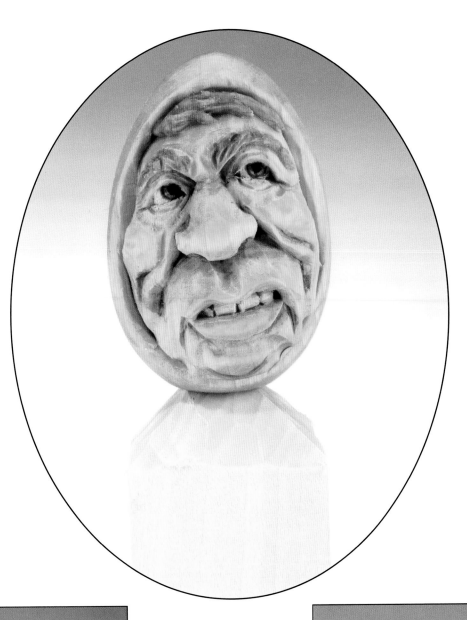

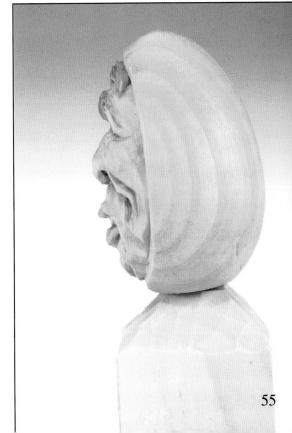

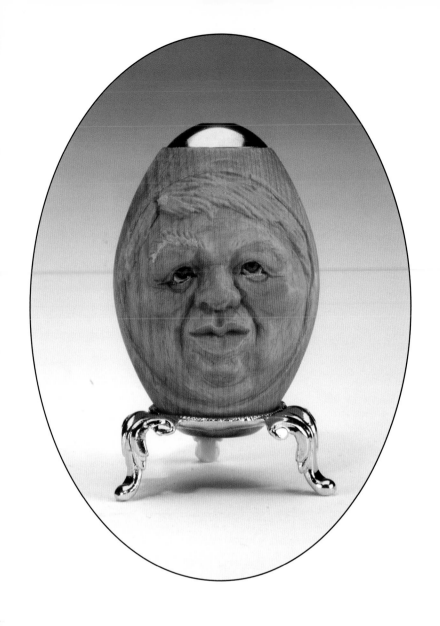

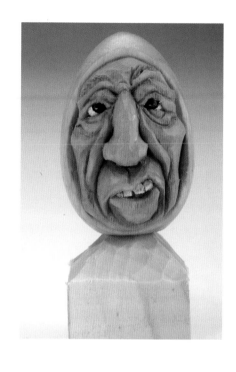

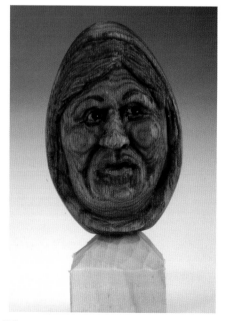

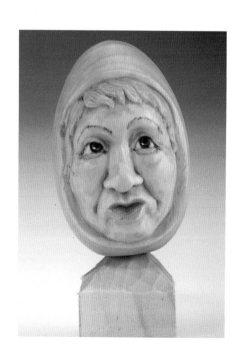

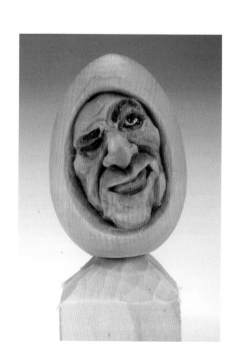

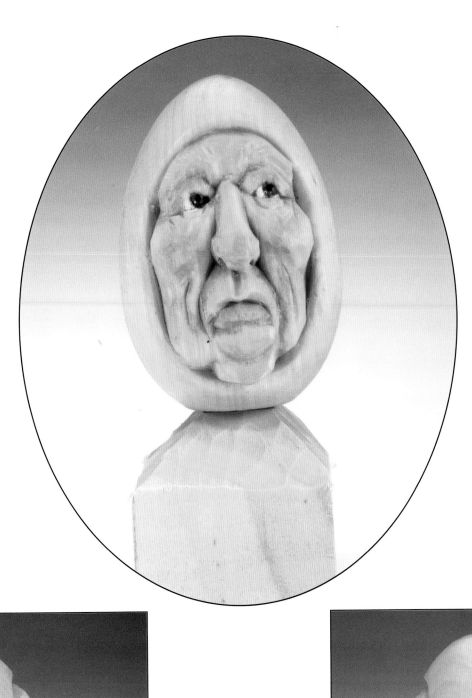

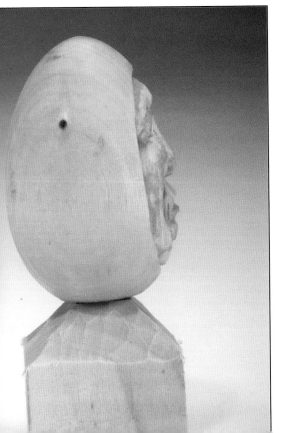

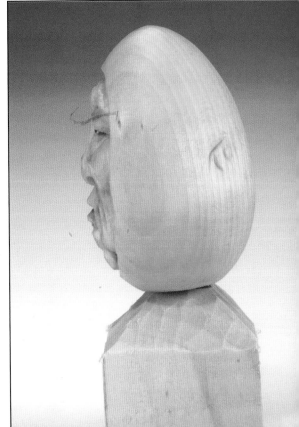

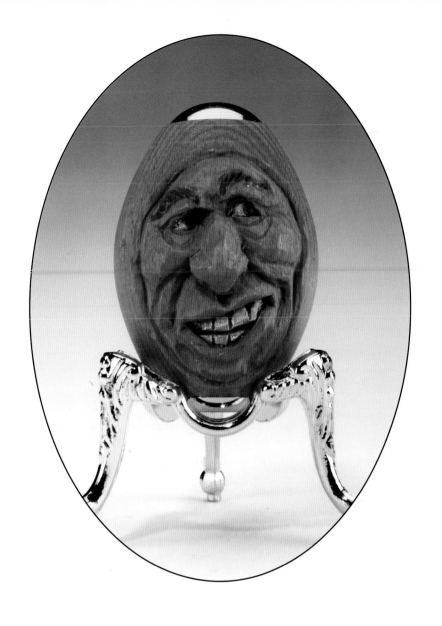

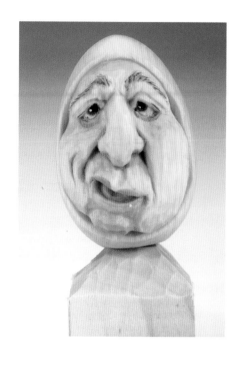

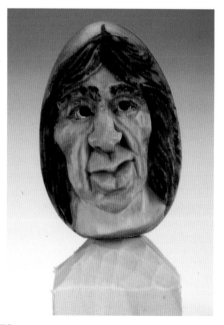

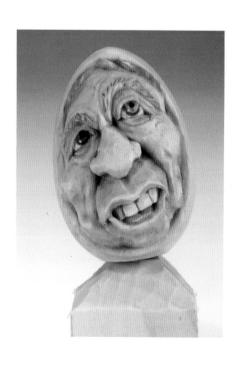

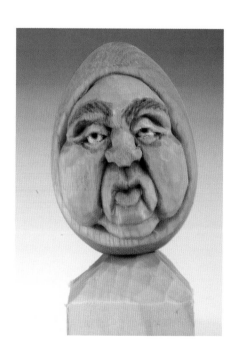

58

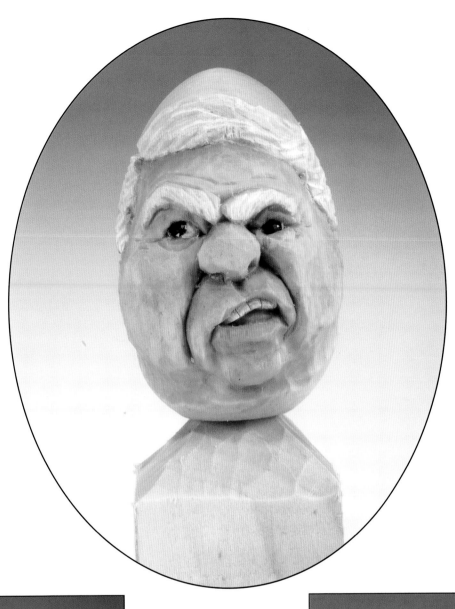

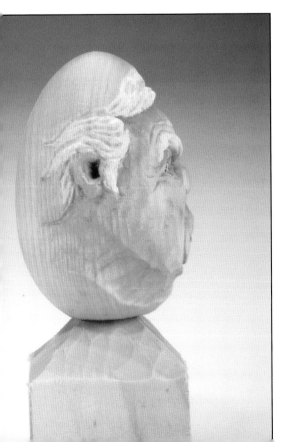

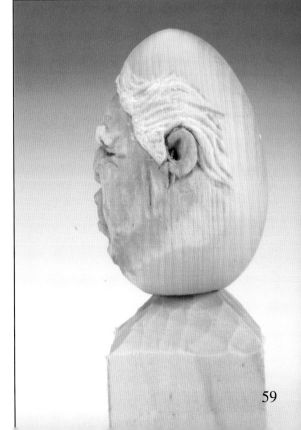

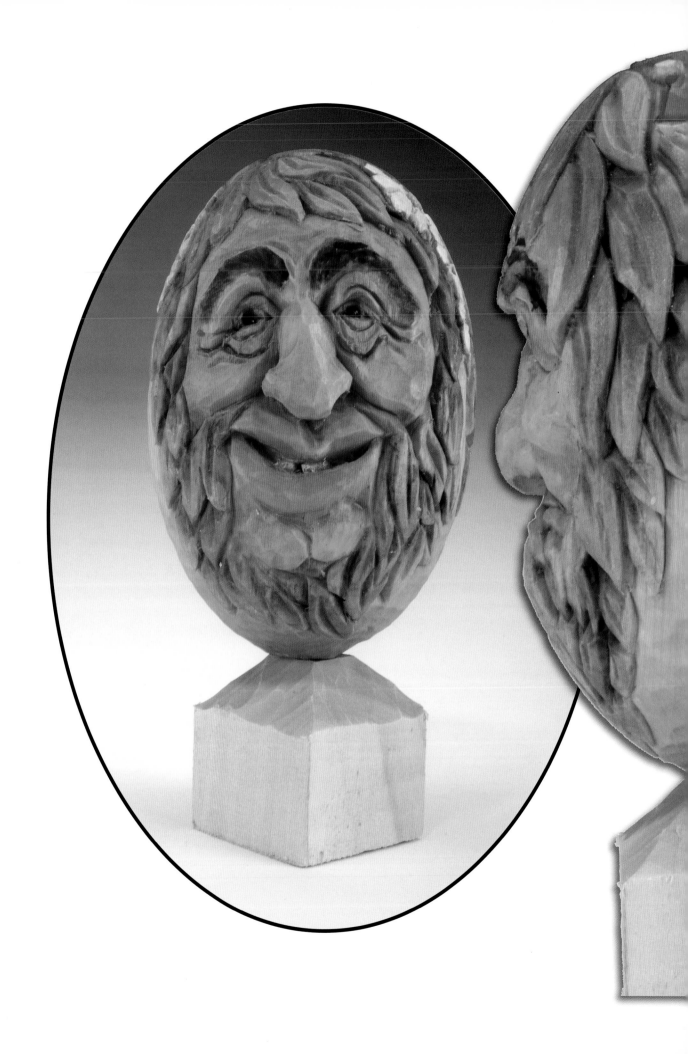

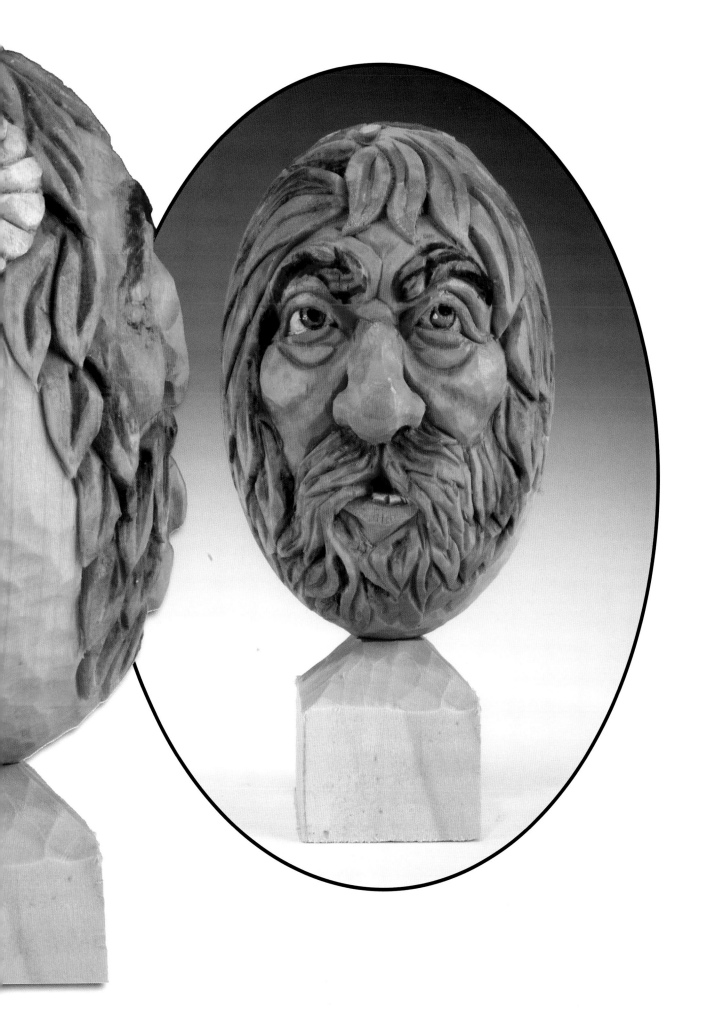

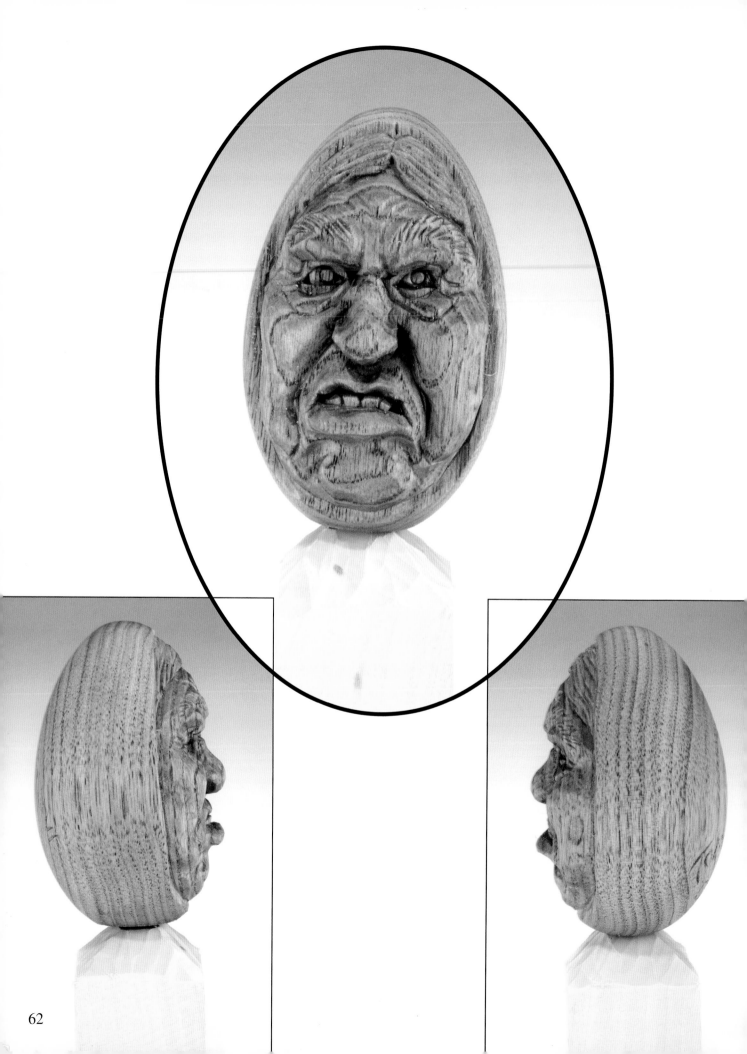

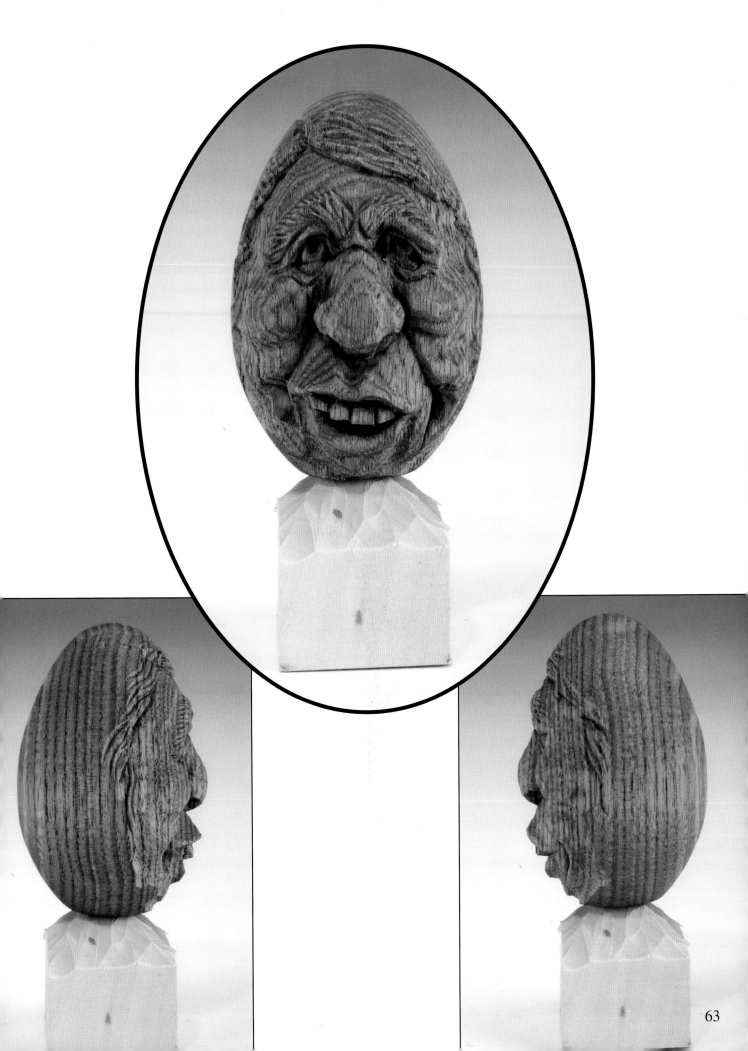

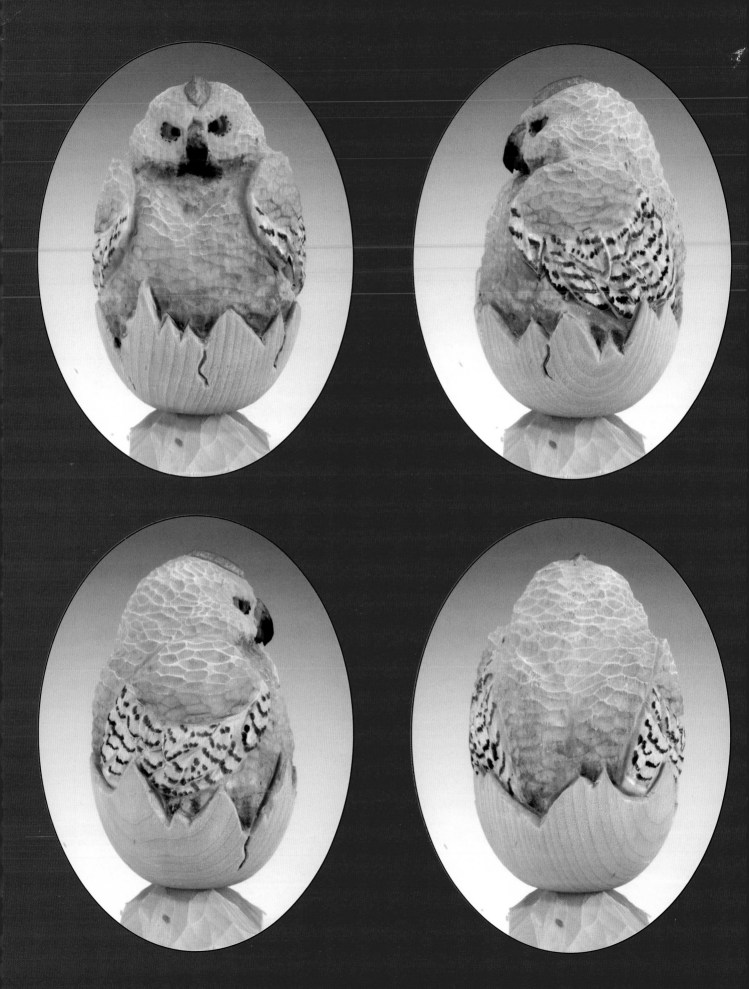